P9-DWK-263

Horses and Their Women

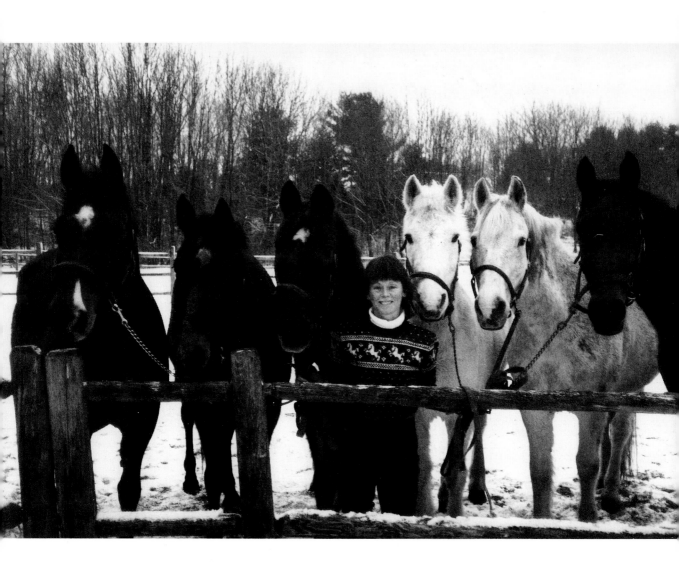

PHOTO: Paul Bezreh

*Ellice Bezreh with Brie, Tam,
Woton, Deppy, Sebastian, and Tex*

Horses and Their Women

Barbara Cohen and Louise Taylor

LITTLE, BROWN AND COMPANY
BOSTON NEW YORK LONDON

Copyright © 1993 by Barbara E. Cohen and Louise Taylor

All rights reserved. No part of this book may be
reproduced in any form or by any electronic or mechanical
means, including information storage and retrieval systems,
without permission in writing from the publisher, except
by a reviewer who may quote brief passages in a review.

First Edition

Library of Congress Cataloging-in-Publication Data

Cohen, Barbara
 Horses and their women / Barbara Cohen and Louise Taylor. — 1st ed.
 p. cm.
 ISBN 0-316-15051-7
 1. Horses — United States — Anecdotes. 2. Women horse owners
— United States — Anecdotes. 3. Horsemen and horsewomen — United
States — Anecdotes. 4. Horses — United States — Pictorial works.
5. Women horse owners — United States — Pictorial works. 6. Horsemen
and horsewomen — United States — Pictorial works. I. Taylor, Louise.
 II. Title.
 SF301.C54 1993
 636.1'0082 — dc20 92-26924

10 9 8 7 6 5

RRD-VA

Printed in the United States of America

For Little Bobbi and Little Wumpkins

Acknowledgments

MANY THANKS to the hundreds of women who sent photographs, stories, and heartfelt letters to us about their horses. The love for their equine companions expressed therein provided the momentum we needed throughout the project. We are especially grateful to the women pictured on these pages and their photographers, whose contributions made this book possible.

No words can convey our gratitude to Margie Arnold for her photography, unyielding enthusiasm, and support from start to finish. We would like to thank Staci Layne Wilson for encouraging us to do this book; Shelby French, who helped with horse statistics; and Sarah Pence for reviewing the manuscript. Louise's weekly trail rides with M. F. Crocket and her horses Windy and Hawk were invaluable in her gaining experience and more horse sense, as well as reacquainting her with the sheer joy of riding. Thanks to the Martha's Vineyard Historical Preservation Society and especially Alison Shaw, who arranged to stop the Flying Horses Carousel for us. We would like to express special thanks to Louise's trainer, Leslie Lonergan, for her encouragement and expertise, and especially for helping to find Louise's first horse, Frankie. Many thanks also to all the people at Arrowhead Stable for their help and guidance.

We wish to thank our friends and family and the following people, organizations, magazines, and journals for their support and assistance: *America's Farrier's Association Newsletter;* the American Horse Council; Debba Armer; *Art Calendar; Artist's Resources Letter* of the School of the Museum of Fine Arts, Boston; Suzy Becker; the *Boston Globe;* Judith Boynton; the *California Horse Review;* the *Chronicle of the Horse;* Sue Copeland of *Horse & Rider;* Diana De Rosa; the Delta Society; the *Equestrian Connection; Equus; Fjord Herald;* Jennifer Fusco of *Horsemen's Yankee Pedlar;* Ellie Garber; Sharon Glick; *Horse and Horseman;* Horse Industry Directory; *Horse World USA; Inside International;* Robbie Kaplan; Sharon Ralls Lemon of *Horse Illustrated;* Rose Marston; Eva Marie Morris of *Practical Horseman;* Mary Rose Paradis; *Peruvian Paso Horse Newsletter;* Cindy

Phillips; the *Quarter Horse Journal*; Suzanne Sanders of the Missouri Fox Trotting Horse Breed Association; Carol Urbans of *Pony Club News*; Deb Van Batenburg; Lorrie Webb; *Western Horseman*; and the Williams family.

Thanks to Jennifer Josephy and Little, Brown and Company for giving us the opportunity to publish this book. A special word of thanks to Laura Smith for her encouragement and expertise throughout the project. We could not have done this book without our lovable cat Coopie and our wonderful black Labs, Gabe and Glory, who stood by our sides patiently waiting for their overdue walks. Partly because of this book, Coopie, Gabe, and Glory now have a big Appaloosa brother called Frankie. Last, the spirit of the horse deserves the final thank-you for giving girls and women of all ages fulfillment, challenge, companionship, friendship, and love.

PHOTO: Margie Arnold

Barbara Cohen and
Louise Taylor

Introduction

RIDING ON A PARENT'S KNEE was our first horselike experience. Then came pony rides, enchanting carousel horses, and, for a quarter, a ride on the plastic Palomino at the five-and-dime. Growing older, we pranced around our backyards and across nearby fields pretending to be horses. We soon began to dream of having a horse of our own. When our bedroom walls became completely covered with horse pictures and our bookshelves held only china horses, our friends and family labeled us horse-crazy — a phase we were supposed to outgrow. But we think the dream of having a horse of your own never dies. This book is about dreams coming true. It's a celebration of the loving relationship women (and girls) have with their horses.

In the spring of 1991, a fifth printing of *Dogs and Their Women* was under way and the manuscript for *Cats and Their Women* almost finished. Louise felt it was time for a break, but Barbara, anxious that we provide a forum for women to share their love for horses as well as dogs and cats, began doing research for the third book. The truth was, having taken up horseback riding again after thirty-two years, Louise was more interested in riding than working on another book!

In response to notices placed in national and local equine journals and magazines, we received more than three hundred photographs and letters over the course of a year. The letters were encouraging and enthusiastic and gave us a broad range of material. There was something new every other day, and as the collection of material grew, so did our excitement about this book. We knew what we wanted the final manuscript to *feel* like but were surprised and delighted with the diversity we achieved.

So tack up, tuck a handkerchief in your sleeve, and meet some terrific women and horses. Ride along a three-mile parade route with Natalie Gammey on Chief and see what mischief they conjure up. Or trot down memory lane with Jan Spink and her horse Copper through their twenty-nine-year relationship. Some of the women, like Victoria Goss, carry a magic wand, tend to unwanted, neglected, and abused horses, and give them a new chance

at life. Others, like Briana London, bought a horse when they themselves needed love and companionship.

Mothers of "horse-crazy" girls have a few words to say here too. Ann Mixson tells of being eventually won over by her daughter's "naughty and outrageous pony" Dandy, and Joyce Hazelwood shares the tale of how her dream of riding in the Thanksgiving Day Fox Hunt with her daughter was finally realized.

Horses and Their Women is a tribute to women and their passion for horses, to their courage, skill, and athleticism. Most important, it's about love and the precious experience of having a horse of your own. We hope every girl or woman who dreams of someday owning a horse will see that dream come true.

Horses and Their Women

IT TAKES TIME to get close to horses, get to know them. They're strange creatures — utterly individual, unpredictable, and powerful. And yet they allow us to get close, to care for them, groom them, and ride on their backs. There is plenty of work involved. It takes a lot of time and holds as many frustrations as challenges. There are bad days in training when everything is a struggle, and moments when the connection is so complete that the flow of muscle and motion beneath you feels internal.

Creating a partnership with my horses and keeping them healthy, fit, and safe is a way of life. A kind of trust comes into it that takes hold of you. It's hard-won and a gift at the same time.

PHOTO: Beverly Hall Photography *Sarah Pence with Dory and Brennan*

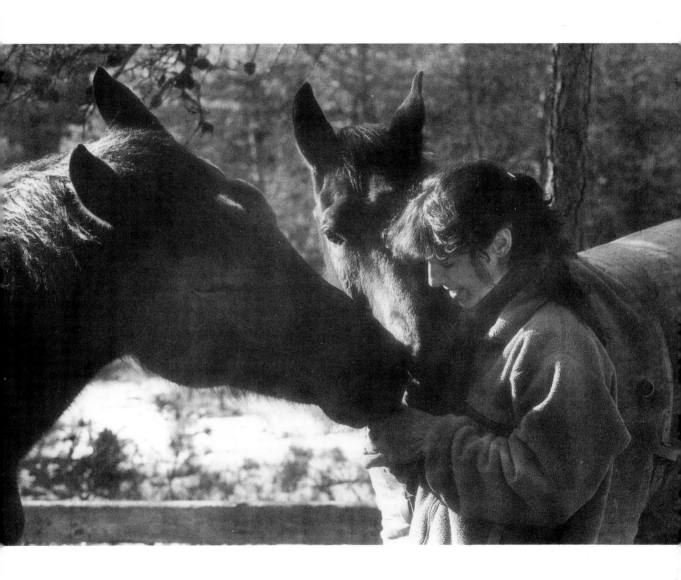

I GOT MY FIRST HORSE when I was thirty-five. I call him Black, or sometimes Beauty, though his real name is Admiral's Josh. We had a difficult beginning because I was just learning to ride and he was only five years old. I sustained a number of sprains and fractures, but after a year we came to know and to trust each other. We were just beginning to show well when Black turned up navicular, an incurable degenerative disease of the navicular bone of the foot. I tried every method imaginable to remedy the problem over the course of three years. In the end I put Black out to pasture.

Khaleb came home with me after I looked at fifteen to twenty horses. Three weeks later, walking in the pasture, he became unglued and went flying down the fence line, forty miles an hour, bucking and kicking. I couldn't stop him, I couldn't turn him, and before I knew it I was on the ground with my right hand hanging off my arm at a forty-five-degree angle. I had transferred the trust and understanding I had built with Black to Khaleb. It was a mistake.

We were well into the winter when my arm and my confidence had healed enough to begin the slow process of building trust. But Colorado winters at ninety-three hundred feet are rarely conducive to riding, so I waited for spring. Every day I spent time with him, talking, stroking and loving him, and by May that gangly, frightened colt had learned to love me.

We continue to work slowly toward our first show. We're in no hurry.

PHOTO: Susan Baker *Elana Hanson and Khaleb*

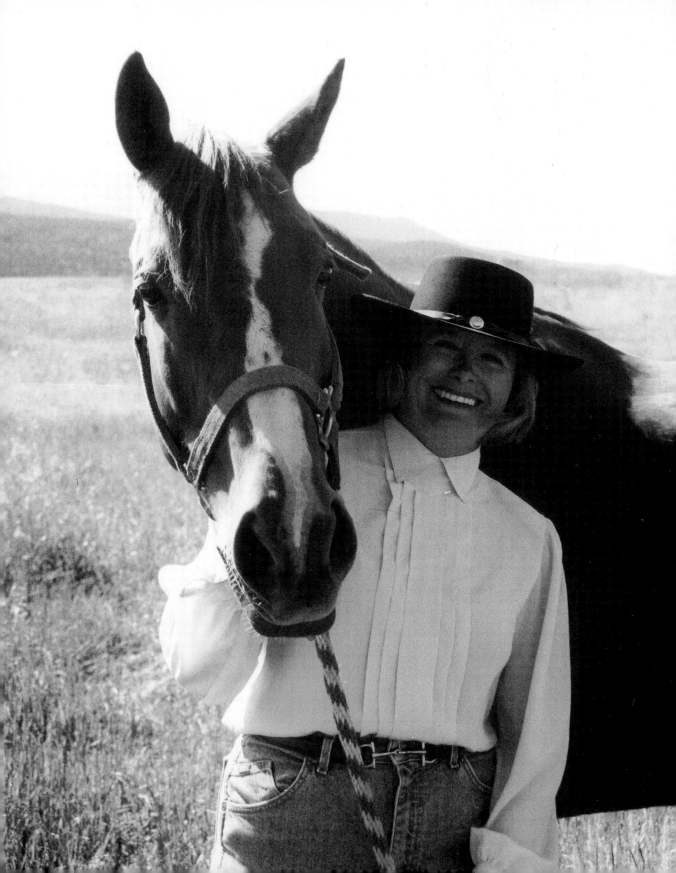

WE HAVE JUST SUCCESSFULLY FINISHED a challenging jumping session, and Tempus is excited. It is very cold outside. He prances about the field looking sideways into the next pasture at the nearby horses to make sure they have seen his glorious leaps and bounds. Of course they are uninterested and nibble hay with bent heads.

I, at least, am pleased with his efforts and later present him with a tasty warm bran mash with carrots, apples, and just enough molasses to warm his winter tummy. Tempus thanks me with nickers and nuzzles.

PHOTO: Victor Fisher

Jennifer Corrigan and Tempus

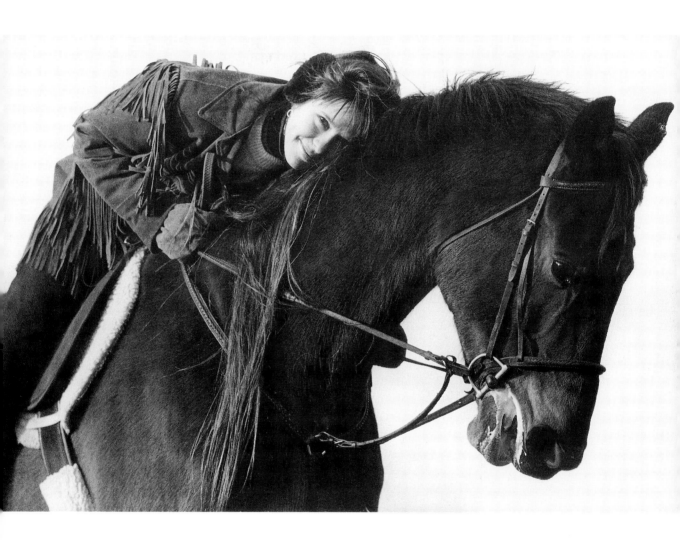

I WENT TO HOLLAND for the weekend, saw Sauvage, and thought he was sexy. So I bought him.

*Loretta Van der Veer and Sauvage Diamant
(1989 U.S.D.F. Horse of the Year.
Won All-Breeds Award by the North American
Department of the Royal Warmblood Studbook of the
Netherlands and was one of only nine stallions
to receive a licensed status with the NAWPN in all of
North America since 1983. Sauvage was the 1992
Grand Champion of the NEDA BREED Show.)*

PHOTO: Terri Miller

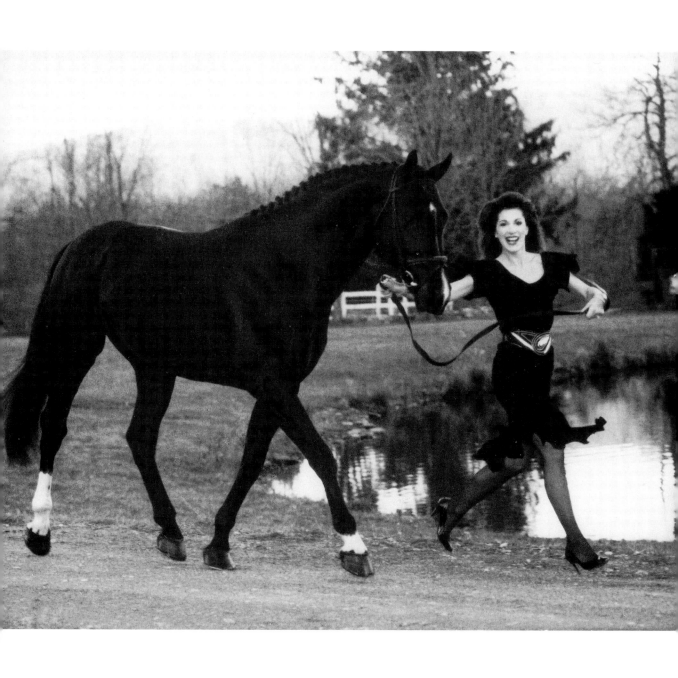

BOTH MY DAUGHTER JENNIFER AND I were born loving horses. I believe it is genetic. No one else in my family is horsey, but it is this shared passion that allowed us to survive a stormy adolescence. Taken at the Stirrup Cup just before the Thanksgiving Day Fox Hunt at Myopia, this special photo captures the beginning of an adult friendship between mother and daughter. Since Jennifer was born I had dreamed of someday riding the Thanksgiving Hunt with her, and here we finally did.

PHOTO: Cornelia Walsh

Jennifer Young and Epheran,
Joyce Hazelwood and Doctora

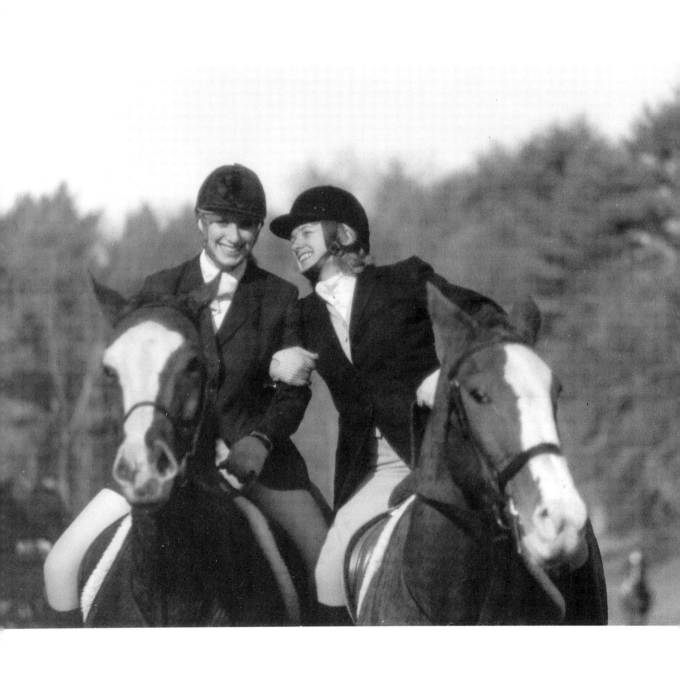

THIS FALL Bourbon and I were trail riding with two other riders. Leaves covered the ground and the trails. When we came to a tree down across the trail, the two other riders went around the obstacle, and Bourbon and I started to follow. Bourbon stopped, tried to continue, but couldn't. When I looked down, I saw that his back legs were hung up in barbed wire. I got off him slowly while trying to talk to him calmly — my voice was starting to crack, and the tears were beginning to roll. But I knew I had to stay calm. If I got Bourbon upset, he'd tear his legs to pieces. I asked one of the other riders to hold him at the reins. I had to be the one to untangle him because he trusts me. The whole time I was working to free him, he didn't budge. I freed his legs and he stepped out slowly. The ordeal ended, but the love and trust will always be there.

PHOTO: Denise Hellmann

Gina Mahaffey and Bourbon

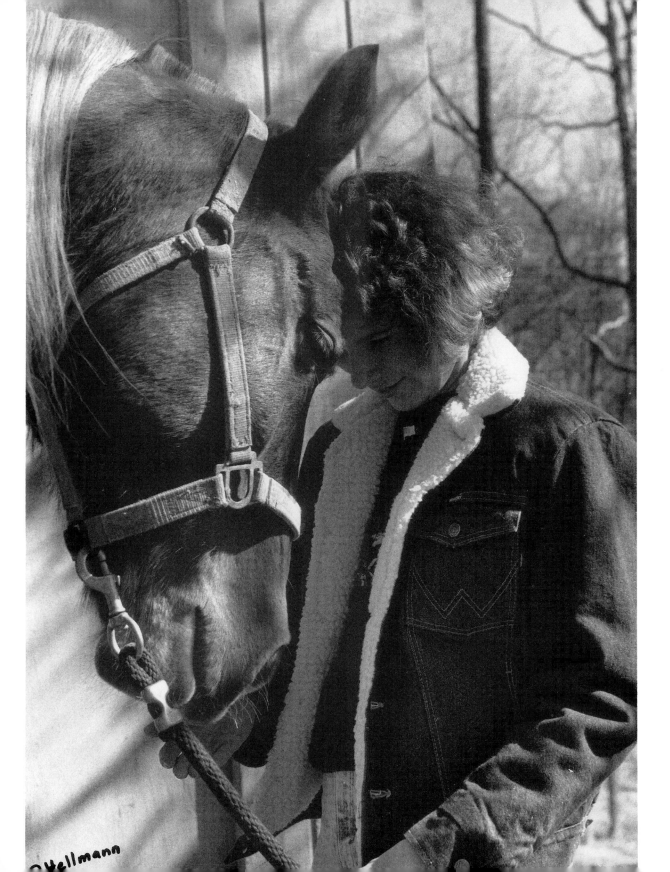

Hellmann

SEPTEMBER 23, 1991, was the day I began my training to become a certified mounted police officer with the Boston Police Department. Having a love for horses, I felt privileged and happy to be a part of the unit. At the time my career was moving forward, my private life was disintegrating — I was a battered woman.

In mid-December, about two weeks before I was to be certified, my husband burned down our family's home. In spite of this tragedy, I continued my training and became certified. I couldn't have found the strength to finish my training without the love I received from my new horse and partner, Mariah. Mariah has helped me find peace of mind, hope, and the courage to continue my life.

PHOTO: Margie Arnold

Shelley Bynoe and Mariah

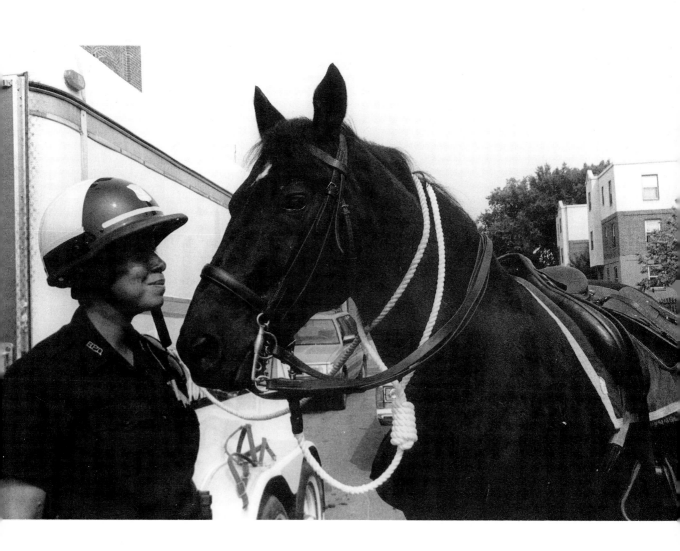

AS AN EQUINE JOURNALIST/PHOTOGRAPHER I have traveled the world with tape recorder, pen, and camera in hand, documenting the lives of great horses and their riders. My life has been a whirlwind, and I owe it all to my love of horses, and to my thirst for spending as much time with them as possible and learning as much about them and those who surround them as I can. I am indebted to the horses of the world for making my life as full and wonderful as it has been.

PHOTO: Kerriann Flanagan-Brosky

Diana De Rosa and Innisfree
(owned by Julia Steinberg)

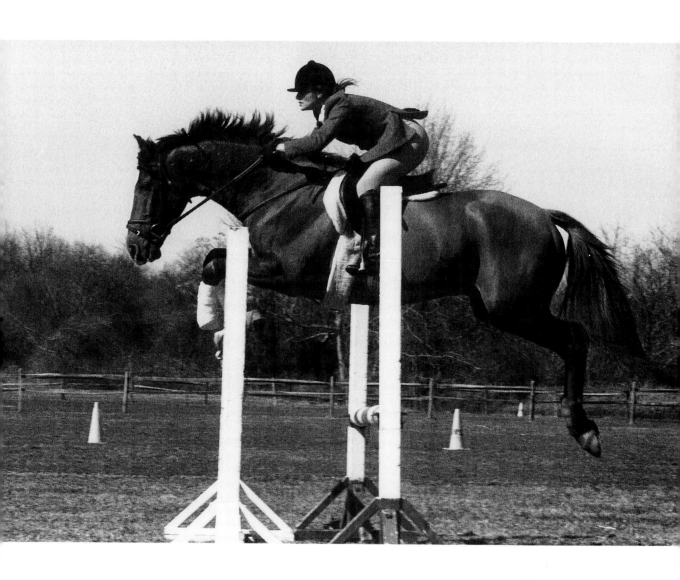

SKEETER WAS THE FIRST HORSE that ever let me ride him. Of course, riding is not really what I was doing, since I promptly slipped off, but Skeeter came over and nuzzled me as if to say "Yo, get up and get back on." I was hooked.

That was over twenty years ago. Since then I've been around horses, and I've still got that feeling that they let us do things to them and they willingly do things for us. I event Tyler, and I'm convinced that he would try to jump a mini-mall for me if I asked. I can lead this supposedly high-strung young 17-hand Thoroughbred blindfolded. He'll follow without a lead, he'll eat anything I give him, he'll let himself be trimmed without being tied, he goes right up a trailer ramp — and why? Some would say stupidity, but I think it's trust. I haven't hurt him yet, so why would he think I'd start?

Lest you think I have the perfect horse, let it be known that Tyler hates dressage.

PHOTO: David Belafonte

Anna Nicholas and Tyler

GET DIVORCED . . . BUY A HORSE" became my motto six years ago when I found myself alone and in need of a challenge. I wouldn't say Mandy and I have compatible personalities, but our relationship works because of the trust earned over the years. The training, the trying, the falls, and, finally, the ribbons have brought me a new self-confidence and a sense of accomplishment; and Mandy's loyalty, her allowance for my mistakes, has re-ignited my compassion and patience. The lessons she's taught me carry through to my professional life as editor for CBS's *Northern Exposure.* Now when a high-strung ego walks into my editing room, I imagine a four-legged creature, head held high into the wind, and I know how to tame it.

PHOTO: Michael Nankin

Briana London and Mandy

WHEN I WAS A VERY YOUNG GIRL, in the days of yore, when rockets to the moon were something you read of in comic books, my imagination soared to the sound of galloping hooves. Magic names such as Trigger, Champion, Silver, Fury, and Flicka thundered across my dreams — dreams of gallant steeds with flaring nostrils and flying manes carrying warriors, cavaliers, masked riders, and brave knights in shining armor.

Perhaps these were strange dreams for a city girl, for I was often told, "Wait until you're sixteen and you'll forget about horses." I waited and worked, but I did not forget, and one day the impossible dream became real. I passed through the gauntlet of childhood to adulthood on the back of my first horse, a sorrel Morgan-Arab mare I named Flame. For twenty-one years we grew and learned together — and we enacted the dream of a knightly champion in costume class.

With the advent of a local Renaissance festival, another dream, too, became real, and the Black Knight galloped forth mounted on a fiery steed to do battle in the lists. No matter that the Black Knight was really a lady in disguise. For sixteen years Flame and I held our place in the lists and rode through adventures that exceeded anything I had imagined. Flame passed on at twenty-five, but by then other steeds such as the gallant Jedi had come along to take her place, if such was possible.

Today the Black Knight no longer rides in festival jousts, but I still don armor and ride forth for parades and other enterprises. Troubles and time pass away when I'm with my horses, and dreams do come true on horseback.

PHOTO: Susan Kluesner *Frances Fignar and Jedi*

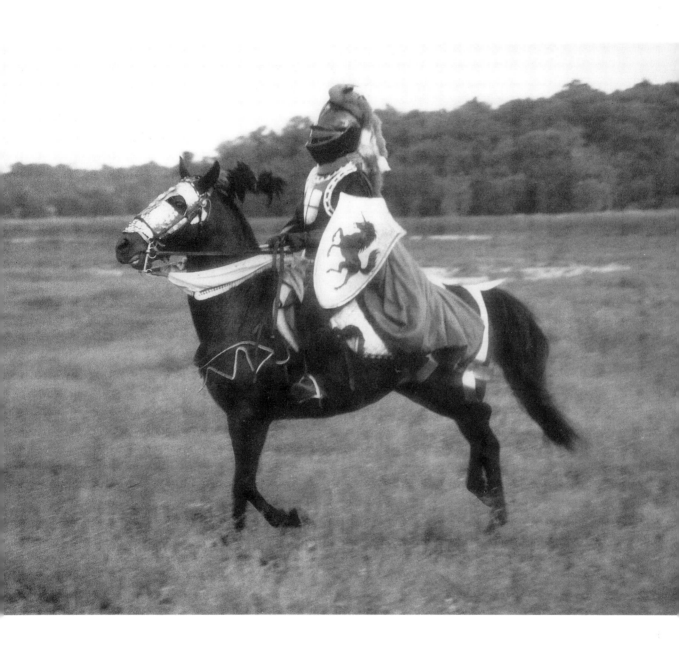

MAGIC WAND is a six-year-old black stallion with whom I've had many successes at the races. He is a pacing Standardbred standing just shy of 17 hands — a beautiful animal with lots of personality. He's a gentle, loving soul to work around yet has a bratty attitude on the racetrack. He loves to win and once in front of the pack is reluctant to relinquish his lead.

PHOTO: Lorene Fara Photo

Kimberly Rinker and Magic Wand

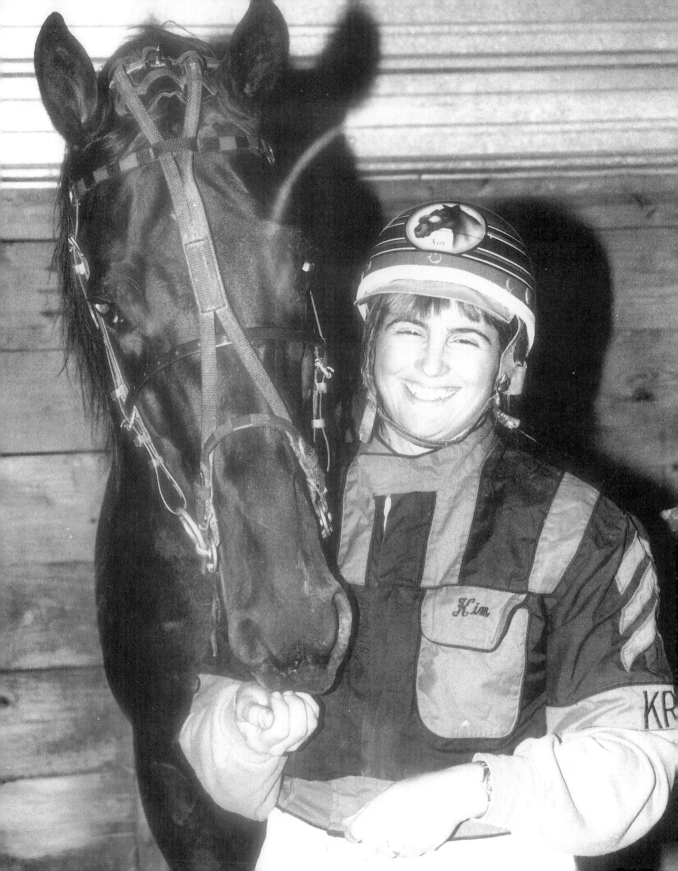

In 1972 a Reno newspaper ran a story about Wilma, a 3,200-pound Belgian Brabant mare who was going to be auctioned off for steaks at the Farmer's Fair in Merchtem, Belgium. I read the article and couldn't stand the thought of this beautiful animal being slaughtered, so I called Belgium and, with the help of a telephone interpreter, arranged to buy her. A special crate had to be made for this horse, who was 18.2 hands, approximately 12 feet long, and 9 feet 10½ inches in girth. And to complicate matters further, Wilma was in foal. It took three months to find a ship and captain that would bring her to the United States. After she arrived in New York, I had to hire a double-decker racehorse van to transport her to Nevada. Wilma finally arrived one bitterly cold January day. Her girth rose to 12 feet by the time she had her 160-pound baby. Sadly, Little Willy lived for only three days.

A circus once offered me $100,000 for a few months of work with Wilma. I turned it down. I had no wish to exploit her. To most people she was just a horse, but to me she was a piece of life that wouldn't have been here if I hadn't read about her and made the effort to save her.

PHOTO: Bob Carroll

Virgie Arden and Wilma,
the day she arrived in Reno

26

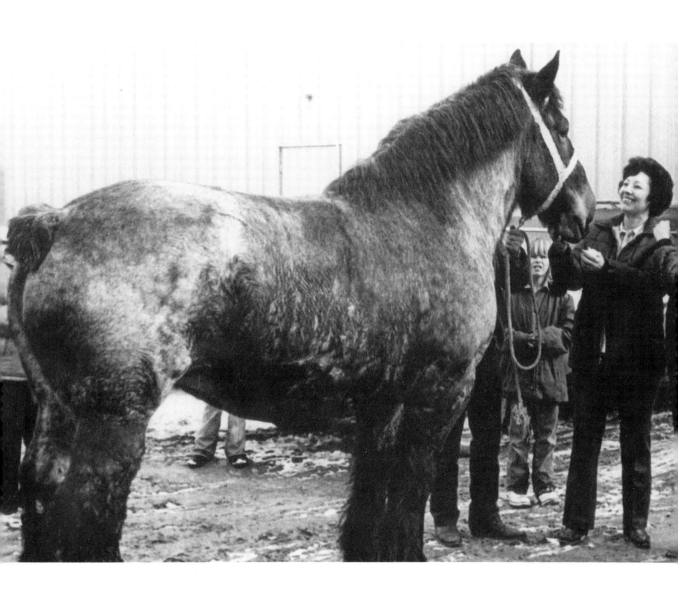

MAY IS my most hectic month of the year. In New England, it is the time that most foals arrive, and not just healthy foals. I have had the opportunity to help provide support and care for over 160 critically ill newborn foals since Tufts University School of Veterinary Medicine, Hospital for Large Animals, started an equine neonatal intensive-care unit in 1985.

My love for foals began shortly after I graduated from veterinary school, in 1978, when people were just beginning to realize that the adage "survival of the fittest" might not be true for the newborn baby. Much of the early work that was done for the neonatal foal was extrapolated from work done with human infants. It was found that with the right care, sick foals not only lived but thrived and prospered.

The two foals in the picture are special babies. The standing foal, Tufts Stuff, is a mini-horse whose mother had been brought to the hospital for emergency surgery. Two days after surgery, the mare went into premature labor. The foal was delivered immediately. The filly required intensive care for a few days, but soon both mom and foal went home happy and healthy.

The larger foal, Sooner, lying on the heated water bed, was born late one night. After her twin had died in utero, she was brought to Tufts with widespread bacterial pneumonia and fractured ribs. She was truly a miracle baby. Despite respiratory failure and having to be assisted by a mechanical ventilator, Sooner survived and flourished. At the time of this writing she was eight months old, strong and beautiful.

PHOTO: Margie Arnold *Dr. Mary Rose Paradis with Sooner and Tufts Stuff*

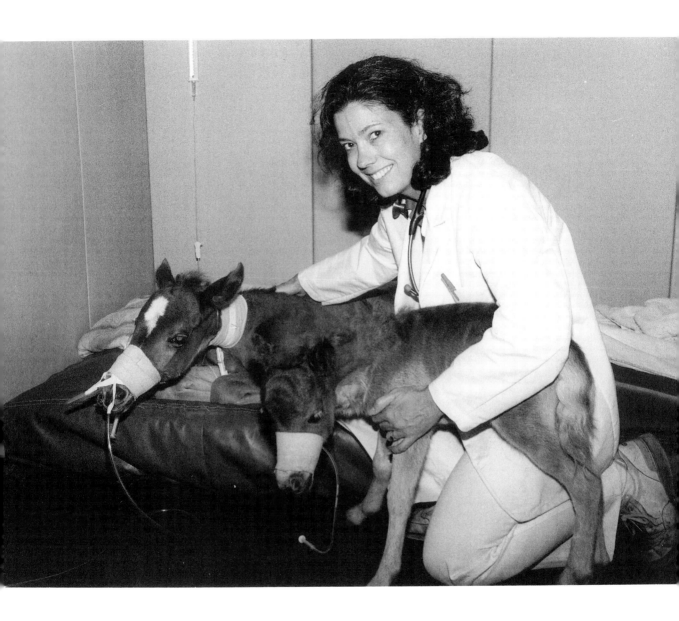

HARMONY IS WONDERFUL. When I'm sad she cheers me up. When I'm happy she encourages me with a warm whinny. When I'm nervous she can feel it and always does her best to keep me safe.

Harmony, August Harmony, I know what it's like to have a bit in your mouth!

PHOTO: Joseph P. Nadeau

Briana Nadeau and Harmony

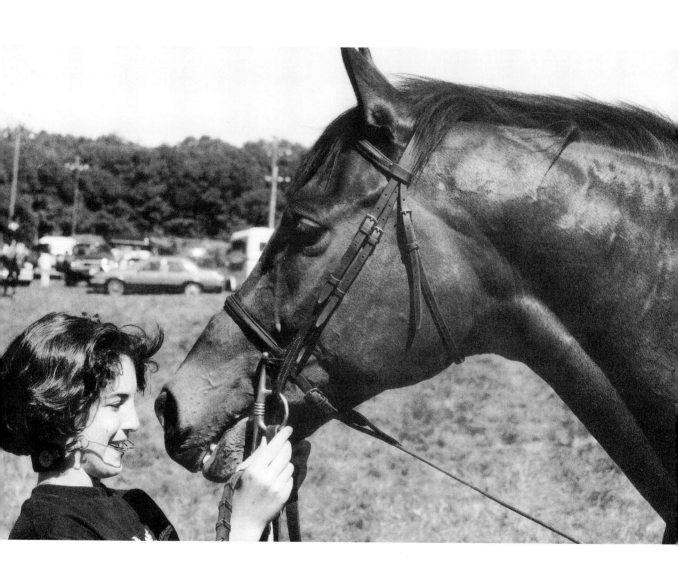

SEMINOLE QUEEN is an overo Paint mare who was once owned by a wealthy man as a broodmare. When cancer developed in one eye, she was hauled off to a wildlife sanctuary to become food for the tigers. But this was not her destiny, and she became a resident of my ranch instead.

I use humor to put people at ease about Seminole Queen's empty eye socket. Since her ear is bent over on the same side as the empty socket, I tell some people I was intoxicated when I bought her and saw only her left side with a long flowing mane and beautiful blue eye. With others I feign shock and say she had the eye that morning when I fed her.

There are advantages to having a one-eyed horse. I can sneak up on her in the pasture with a bridle. When I give her a bath, I don't have to worry about getting soap in her eye. Seminole Queen doesn't get alarmed by the beach ball we use in cowboy polo — she doesn't even see it. We once finished first in a pole-bending event. The rider in second place explained that his horse had never seen the poles before. I told him mine still hadn't.

PHOTO: Valerie Carnes

Connie Turner and Seminole Queen

Six months after saying "I do," I became the proud owner of an Arabian filly named Azure. In our sixteen years together, Azure has given me a roomful of trophies and ribbons, seven lovely foals, and six grand-foals, and she has graced the covers and pages of many magazines and calendars.

As much as I loved owning and breeding Arabians, caring for them while being married and having a full-time job left me with no time to enjoy them. Then last year, while paging through a magazine, I saw an ad with a photo of a tiny foal standing on a man's outstretched hands. I knew I was looking at the answer to my dilemma — the American Miniature Horse.

Azure is still the queen of our pastures, but now her new friends are only about thirty inches tall. She regards them as foals and keeps watch over them even though they are mature and fully grown. I, too, am thrilled with my delightful tiny equines. They are intelligent, eager to please, and quite puppylike in their playfulness and affection toward people. I spend a great deal of time watching the two young stallions playing soccer with a plastic ball. While my friends go trail riding on weekends, my husband and I go hiking with several minis bouncing down the trail with us.

Karen Winston and Evans Picasso,
an American Miniature Horse

PHOTO: Marilyn McKeone

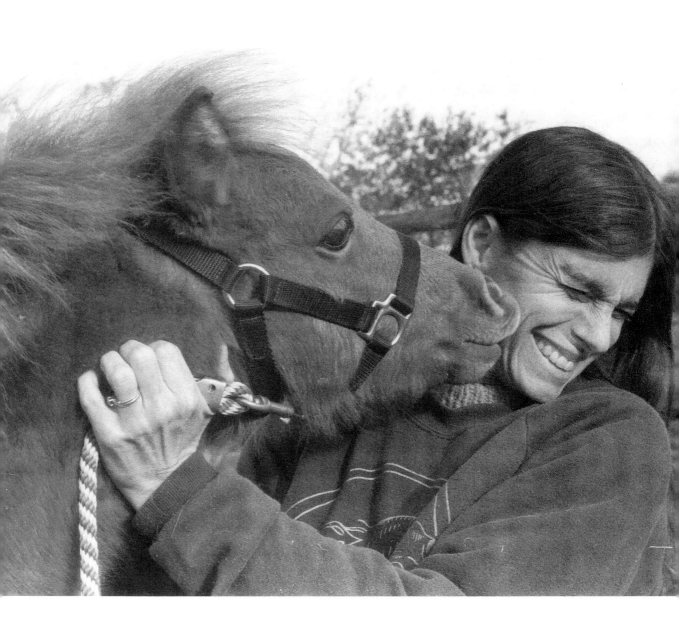

YOU WERE BIGGER in life than life itself. The memory of your perfect form and bold and gentle actions shall be as vivid as your heart and loyal devotion to your mistress, to your careers, to your friends.

You were the impossible dream come true; you reached the unreachable stars; you climbed the highest mountains; you were popular and powerful and proud in your walk through life, and in death.

You had a purpose — you touched so many lives. You demanded and commanded respect. You were admired and loved by many; you were hated and feared by some. You left your name in the record books forever, daring the world to try to equal.

Old faithful pal of mine, we rode together in every kind of weather. Your work days are all over. You are now in pastures white with clover. Your bridle and saddle are now hanging; your gold stirrups are now on the mantel. Your hoofbeats are now silent; your stall is now vacant. Your brown eyes and warm neighs are missed each day.

You were in life and in death THE SHOCKER. You gave all — you made my life full. May your spirit ride with me in faith, and hope, and love.

Peace to you, my true champion.

With feelings forever, until we meet again, your owner-trainer-rider Betty Sain, October 20, 1981.

PHOTO: Les Nelson

E. F. Betty Sain and Shaker's Shocker,
1966 World Grand Champion, Walking Horse

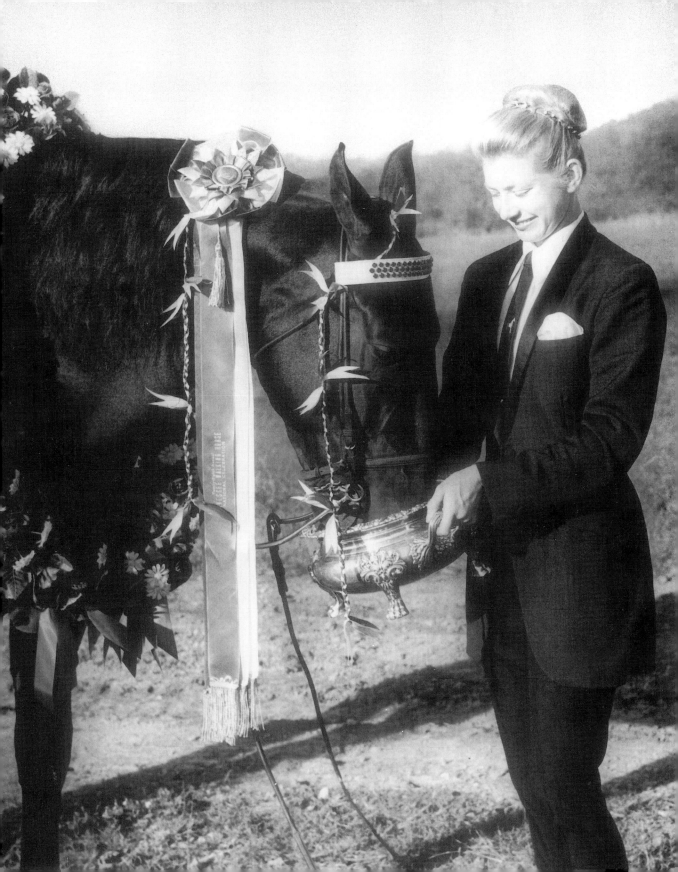

I'LL NEVER FORGET doing cartwheels across the living room floor and whooping like a wild child when I was told that Smokey Jett Jr., the Icelandic pony I had been caring for and riding, was my birthday present. I immediately ran outside and hugged his shaggy neck and planted an enthusiastic six-year-old's kiss on his clover-scented velvet muzzle.

Over the next couple of years, Smokey and I competed in many horse shows. He never won a trophy, but with each ribbon that was pinned to his bridle he became the champion of the world to me. Of course, we did come away with nothing oftentimes too; like the time when Smokey decided to take a good roll in the middle of the show-ring, or when he made a beeline to my mom at the arena rail, hoping to score a treat. As with most ponies, the way to Smokey's heart was undoubtedly through his stomach. He loved anything humans ate, including soda (he could drink from a can or a bottle without spilling a drop), pizza, french fries, corn chips, corn on the cob, and especially candy — his favorite was Snickers.

Smokey was always there for me, especially when I went through the usual teenage emotional turmoil. I would lay my cheek against his mane and cry softly into his neck, telling him he was the only friend in the world who understood me. Sympathetically, he would nudge me with his muzzle and "tell" me everything was going to be okay.

In later years, after I was married and had begun my career, Smokey was still a major part of my life. Although the years had grayed his muzzle and taken away some of his good health, Smokey was still full of vim and vigor. On one summer day's ride, he pranced and pulled eagerly against the bridle, waiting to be unleashed. I let him go and he soared like an eagle, his little slate-gray hooves beating the ground for only a split second before he was airborne again, galloping like a wild Mustang. The wind whipped my hair and whistled in my ears; I leaned forward, my legs warm against his bare back, my face close to his neck. At the time I didn't know I would never ride my beloved pony again; he passed away peacefully three days later.

PHOTO: Lon Viser *Staci Layne Wilson and Smokey Jett Jr.*

I WAS NINE YEARS OLD the first time I sat on a pony, and I have been riding ever since. My partner, Lorad's Shaker Boy, and I have been doing pleasure and competitive trail riding for the past seventeen years. I've had him since he was five months old, and he will be twenty-one on June 10, 1993. He has racked up over seventeen hundred miles of pleasure riding and over six thousand of competitive with the Eastern Competitive Trail Ride Association.

Fortunately for me, he's a patient pit stopper.

PHOTO: R. G. Gamester II *Marcy Gamester and Shaker Boy*

ALTHOUGH his registered name is Pick A Winner, I call him Winners or Win. He has such an impish personality — he always wants to play the clown before he settles down to work. Instead of being serious for our photo session, he wanted to taste the strings and beads on my belt! Win is a three-year-old gelding, and for almost all of his life he has been a scampish rascal, a loving friend, and my companion.

Winners was trained for racing but had only a brief career on the track because he became ill. He returned home extremely sick due to an allergic reaction to his medicine. I had to nurse him at the same time that I was battling an allergic reaction to my own medication. Both our faces and bodies were swollen and broken out with red, itching hives.

After our recovery I had a glorious ride with Win, accompanied by my friend Brooke Kerns, who was riding Roxie, one of my other horses. It was a particularly beautiful weekend with just a touch of fall in the air. As we rode through the native-scrub-oak-covered hills, plateaus, and meadows beneath the majestic Rocky Mountains, just west of my home, we were strikingly aware of the unity we felt with our horses and the communion this allowed us to have with nature. I didn't know this would be my last opportunity to ride Win. Two days later, I was hit from the rear while driving my automobile. This incident aggravated my injuries from a previous accident and gave me a new set of physical problems. Depression began to set in as well, since I didn't know when or if I would be able to ride again.

Why would a person with a fragile physical condition continue to pursue the rigors of horseback riding, with its potential dangers? All I can say is that the rapport that develops from being around horses for a lifetime is extremely difficult — if not impossible — to deny.

PHOTO: © Joanne Kappel/Obsessions *Peggy Cummings and Winners*

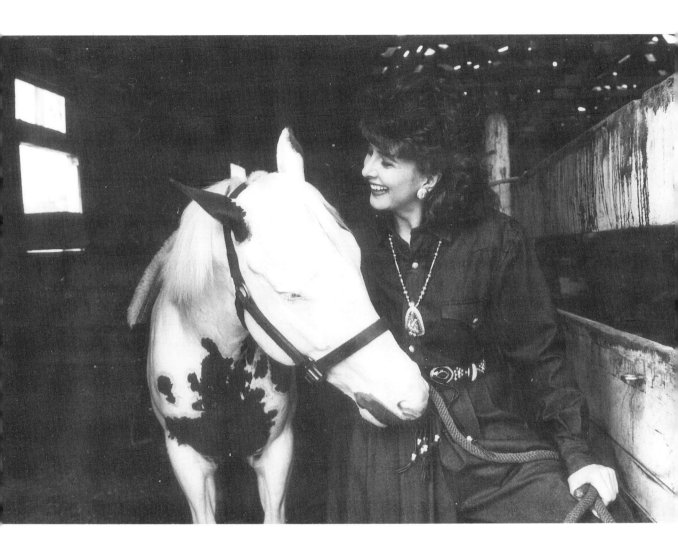

WE RUN about 125 head of horses — a Thoroughbred-Quarterhorse cross that we've been raising since around the turn of the century on our ranch in Montana. I grew up considering horses my best friends. Before and after school, there were no other kids around, so horses became my companions, my playmates, and my pals.

Those early years spent with horses and my father's attitude toward them — that they were just people, like us — have stayed with me throughout my life, and I truly regard horses as a kind of people in horse clothing. They have their own pecking order. They are proud of how they look. Most of the ones I know are not complainers or moaners and groaners; they are faithful, honest, hardworking, and magnificent! I do not baby or pamper them. I don't want to make them into hothouse flowers when by nature they are tough and hardy. Our horses don't need blankets in the winter, hot feeds, or special treatment. They live in the fields, foothills, and prairies year-round, pawing through the snow, eating the cured grasses in the fall and winter, and luxuriating in the lush green native grasses of spring and summer. When they are ridden, they get a gallon of oats a day. How's that for easy keepers?

It is an understatement to say that horses have always been and will always be among my dearest friends. I hope there's a horse heaven!

PHOTO: © Deede Phillips 1987 *Barbara Van Cleve with Shizzers and Huerfana*

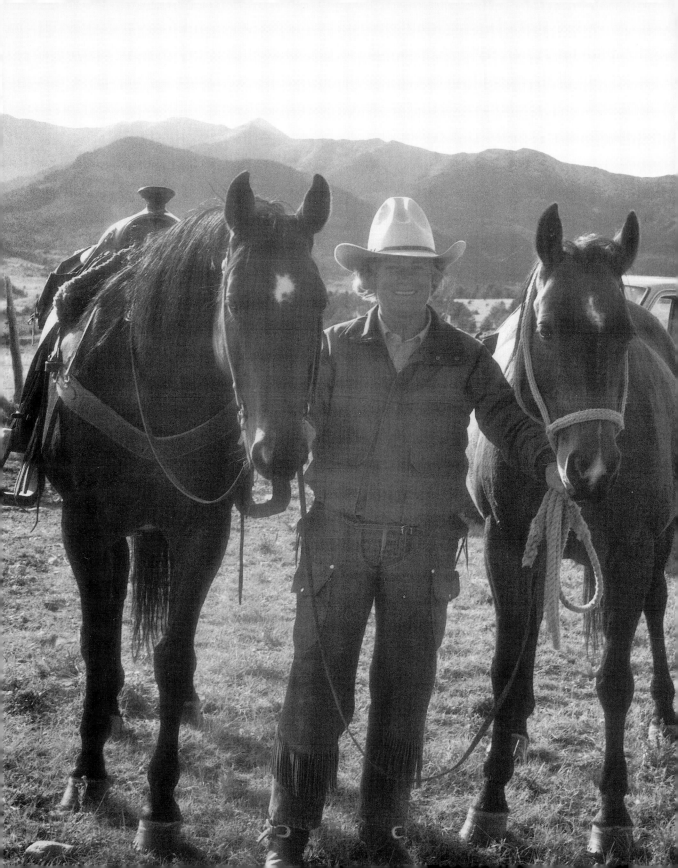

MY NAME IS JENNIFER ROSE. I am ten years old. My horse's name is Rex. He is seventeen years old. I like riding horses and I *love* running barrels. I have won seven buckles and one saddle pad. Rex is my best friend. I go down to his pen and tell him everything. I love Rex a lot.

PHOTO: Emmett Stonestreet

Jennifer Rose and Rex

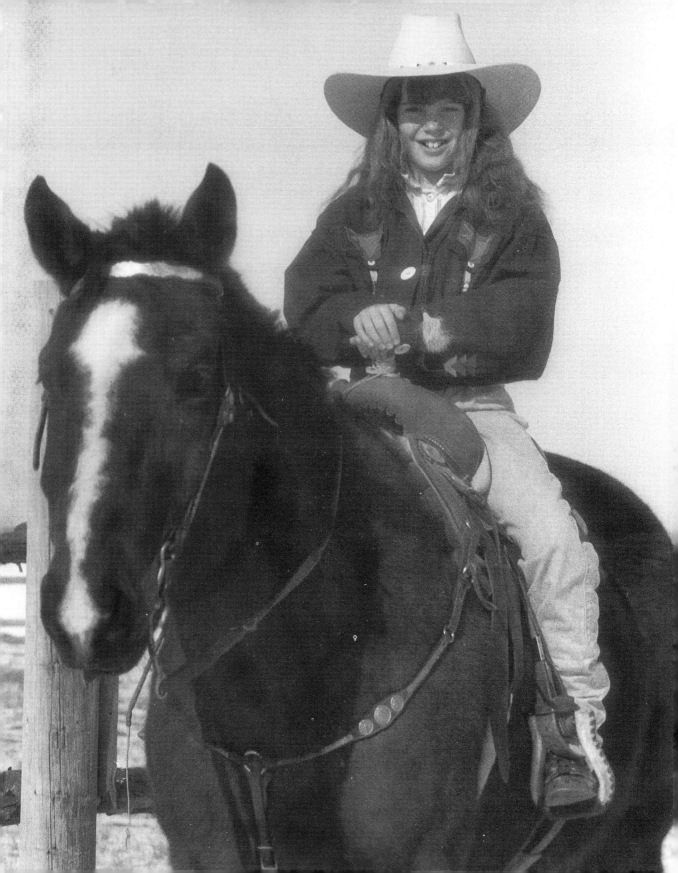

Painted Chief Sees Broadway!" Those were the mini-headlines in the *New York Sun* in the summer of 1942. How did a country horse from Ohio make it all the way to New York City to travel the length of Broadway?

In the spring of 1941, Mildred Binau and I left our homes in Ohio to ride to California just for the fun of it — just we two girls, our two horses, and our saddlebags. I was riding Painted Chief, a brown-and-white half-Morgan, half-Arab gelding. We rode through Indianapolis, crossed the Mississippi River on the Chain of Rocks bridge in St. Louis, and continued west on famous old Route 66. We went through the beautiful Ozarks of Missouri, the old Indian territory of Oklahoma, the grazing lands and wheat ranches of the Texas Panhandle, and continued into New Mexico, where we stayed the night in the famous El Rancho in Gallup. In the morning we rode our horses into the lobby to pick up our saddlebags.

It was 120 degrees as we crossed the Colorado River and entered Needles. We were in California! Almost six months after leaving our homes in Ohio, we rode into Los Angeles and were welcomed at City Hall by Roy Rogers and city officials. From there we rode into Santa Monica and rode our horses into the Pacific Ocean. We shipped the horses by train back to Ohio, where Gene Autry immediately hired Painted Chief and me to ride as advance couriers for his Victory Stampede to sell war bonds. This was in early 1942, after Pearl Harbor. My sister Alma, riding Mischief, and I on Painted Chief rode into Cleveland to join the troupe. While the show played in Cleveland, we rode to Pittsburgh, Washington, D.C., and Baltimore, and then covered the length of New York City on Broadway as ticker tape was showered down on us. Providence was the end of our trip. We then looked for a place to ride into the waters of the Atlantic Ocean and found Rhode Island Sound.

I now own and raise Haflinger horses and use them in a therapeutic riding program for the handicapped.

Although Painted Chief has gone to that happy pasture in the sky, I can never forget that gallant horse who carried me forty-one hundred miles across the United States and into both oceans.

Photo: Lucile Kunkel

Virginia Payne and Painted Chief

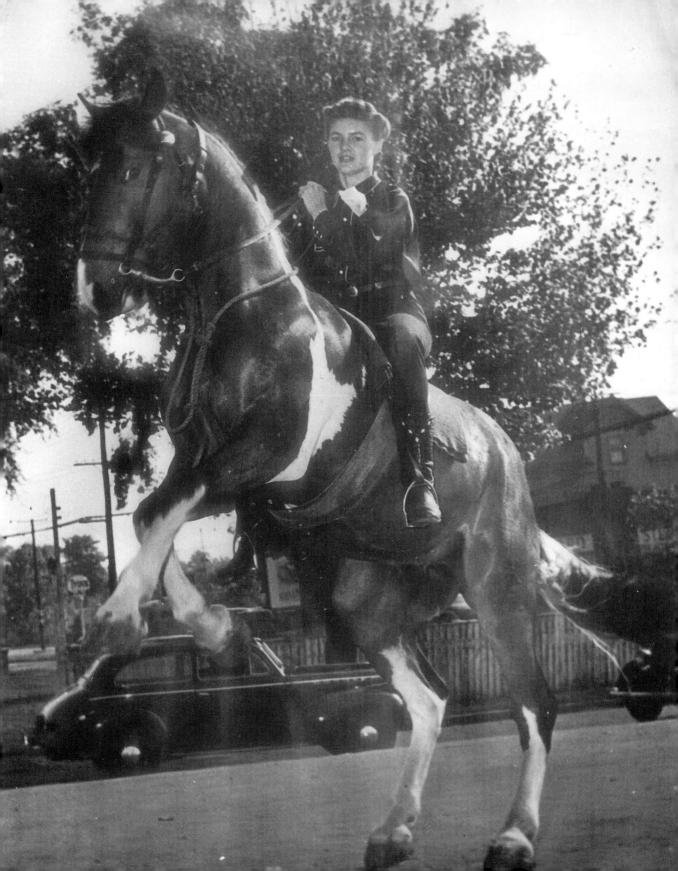

On February 29, 1992, I had to put down my best friend, Flea. It was the hardest and the easiest decision I ever had to make. It was only easy because at age twenty-eight Flea's body had given out and putting her down was the only humane choice. I knew in my heart that I had done all I could for her and that I had given her more love and care than anyone else would have or could have.

I spent that morning alone with her and explained to her what was going to happen before my two vets arrived. Since they knew how much Flea meant to me after sixteen years, neither of them felt capable of handling the situation alone. But before they could administer any medication, Flea pulled away from me, lay down in her stall, and died. The vets were amazed, but I always knew she had a sixth sense and knew what I was thinking.

Now I feel a huge hole in my heart even though I love my five other horses dearly. None will ever replace Flea, and no other horse will ever be as special as she was to me.

Photo: James Leslie Parker

Audrey L. D. Petschek and Bubbles, daughter of Flea

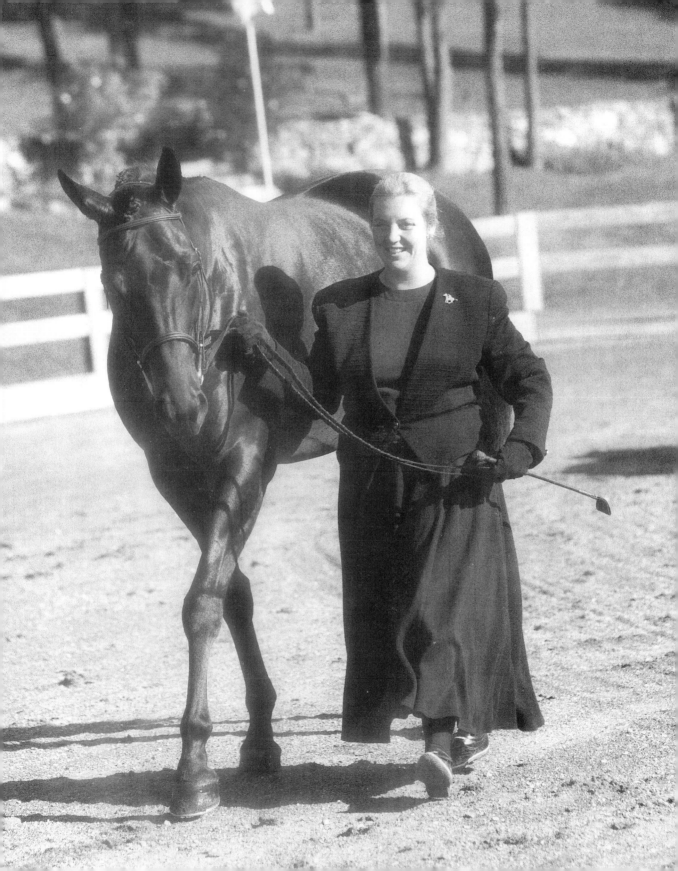

WITH MY HORSE PATRICK, I can be myself. I don't have to be someone I'm not. I can be brave or scared. I can tell him my problems and he listens. He means more to me than any person I know.

PHOTO: Margie Arnold

Juliet Rosenstock and Patrick

I SUPPOSE that I am one of the lucky few who know the joy of having their first pony grow old with them from childhood through adulthood. As I turn thirty-seven this year, Copper, my dear 13.2-hand companion, turns thirty. Our twenty-nine-year relationship started when I was in the second grade and my parents could afford only two hundred dollars for a pony. This was just enough to buy Copper as a twelve-month-old yearling, an investment that influenced the direction of the rest of my life.

Copper fast became my vehicle for personal development. Fancy was not as important as fun in those days, and all my memories of childhood center on the great times we had together. We had swimming parties at our neighbor's creek in the summers, and he'd pull everyone around in a little plastic blue boat. We'd gallop along with a flapping burlap sack in the winter to gather crowfoot and pine cones for Christmas. Then, at age twelve, I grew too tall for him. He went on to be my little sister and brother's pony. When I was sixteen I used him for riding lessons in the summers, and later I started using him in a therapeutic riding program in St. Louis. After many years of working with disabled children, he was put in retirement on my parents' farm. During that time, I moved all around the country pursuing my academic training in rehabilitation and the therapeutic use of the horse.

As the last of our childhood horses passed on, Copper was left all alone at my parents', without any pasture friends or any work to do. I knew that at twenty-four years old he needed to be brought out of retirement and once again given purpose in life. So my mother sent him to live with me again on our new farm in Virginia. When he arrived it was the most wonderful feeling to see that he still recognized me! Since his arrival he has served the smaller disabled children at New Harmony Institute, where he will spend his last days helping them, playing with his herd buddies, and enjoying the security of a lifelong family bond. As I kneel beside him in this photo, he appears to be so enormous. Although it is an optical illusion, it is an accurate reflection of the giant, loving presence he has been throughout the many passages of our family's life.

PHOTO: Susan Earhart Feldman

Jan Spink and Copper

GROWING UP in the city, I had little opportunity to indulge my love of horses. A pony ride here and there, visits to the Boston Mounted Police stables, and reading every horse book I could lay my hands on — these were the things that kept my passion alive.

Finally, as an adult, I started riding seriously. When I think back on some of my less than pleasant experiences with my first horse, I sometimes wonder why I continued.

But then I met Jonquil, and we became partners in a great learning adventure. The road we have traveled together has not been entirely smooth. There have been plenty of ups and downs — both literally and figuratively. In the end, though, we always manage to patch up our differences and start anew. Jonquil has challenged me many times, in many ways, and in the course of meeting those challenges I've learned a lot — about her, about horses in general, and, perhaps most important, about myself.

PHOTO: Genevieve Vileniskis-Wright

Mary Ann Lane and Jonquil

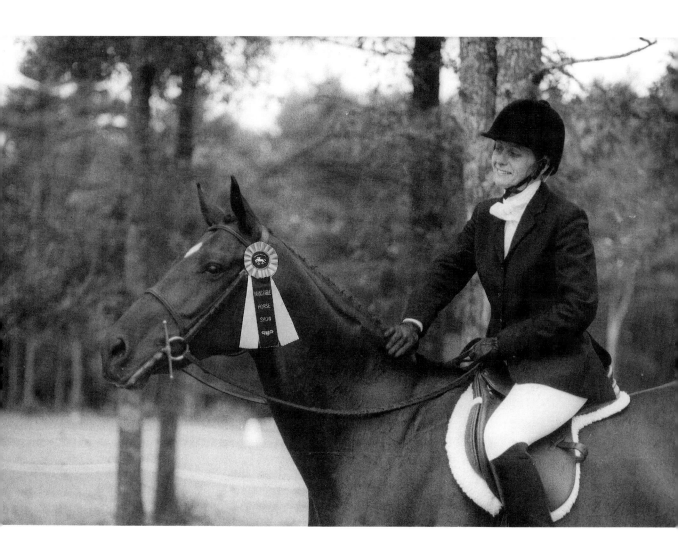

WHEN MY DAUGHTER COURTNEY was seven years old she tried to commit suicide. After twenty-eight days in a children's psychiatric unit she was released. I had been involved with horses in my youth, and Courtney found this fascinating, so I made a point of letting her be around horses; to smell, brush, and enjoy them. Then something happened. My sad, withdrawn, lonely daughter smiled and her eyes sparkled. I promised Courtney I would move heaven and earth to find her a horse, a special horse. Breed was not a consideration; disposition was the highest priority.

Four or five months later my mother went to a used tack sale in nearby Indiana County, Pennsylvania. I telephoned her there to ask if she had found anything. She told me that not only had she checked out the clothing and tack, she had also renewed a friendship from twenty years earlier. This friend listened to Courtney's story and cried, as I again do in writing about it. She then announced that she had the horse that would solve all our problems. There were startling similarities between the horse and child. Both had tragic incidents in their young lives. In the case of the horse, she had suffered starvation and abuse.

That was eighteen months ago. Courtney is now ten and Julia is four. It's great to see them together, and the difference in Courtney is amazing. This year has become one of ribbons, joyful tears, and success for a girl and her special horse.

PHOTO: Michael Clay

Courtney Howard and Julia Moira
Courtesy of Cindy Howard

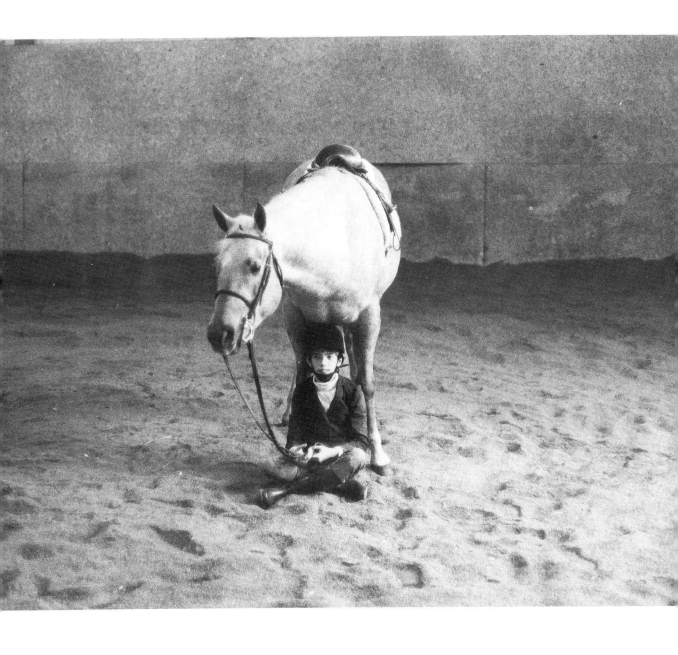

Hᴵˢ ʀᴇɢɪsᴛᴇʀᴇᴅ ɴᴀᴍᴇ is Lord Bob, but I call him Bob, Mr. Roberto, or Mush. Sometimes it seems as though I hocked my life to buy him!

Pʜᴏᴛᴏ: René E. Riley

Shaun N. Cutcliff and Bob

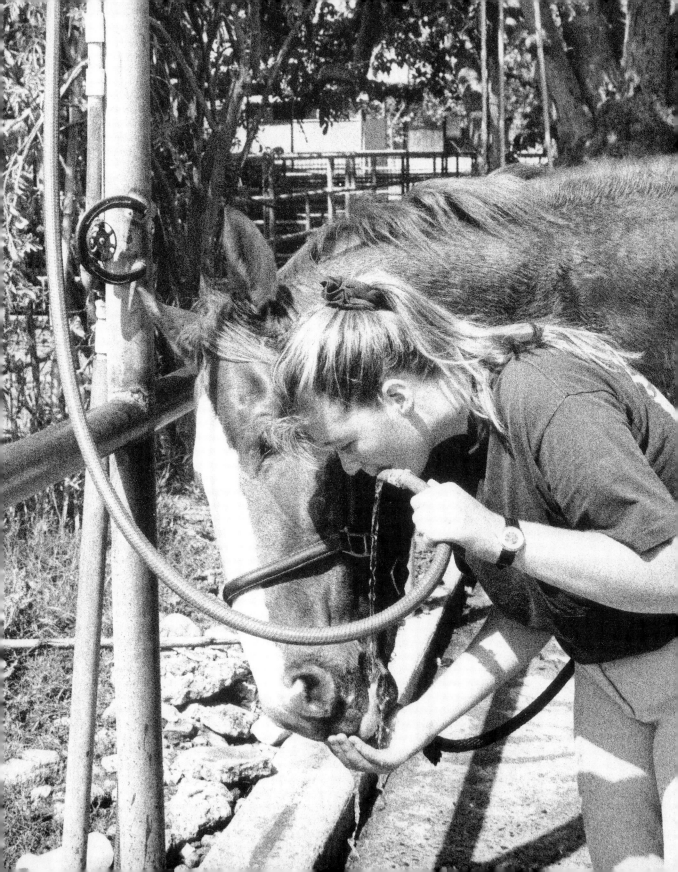

RED and I have been through nine years of tourism together. Not many horses can deal with the center of Provincetown on a Saturday night in August! He has marched past fire engines with sirens and lights going, been in parades with veils from the float in front of him dangling between his feet, and endured much more, all because of his trust in me. He gets jealous of my friends and will stand between us if he can. He's been the cornerstone of my life since 1983.

PHOTO: Marian Roth

Christine Lorenz and Big Red

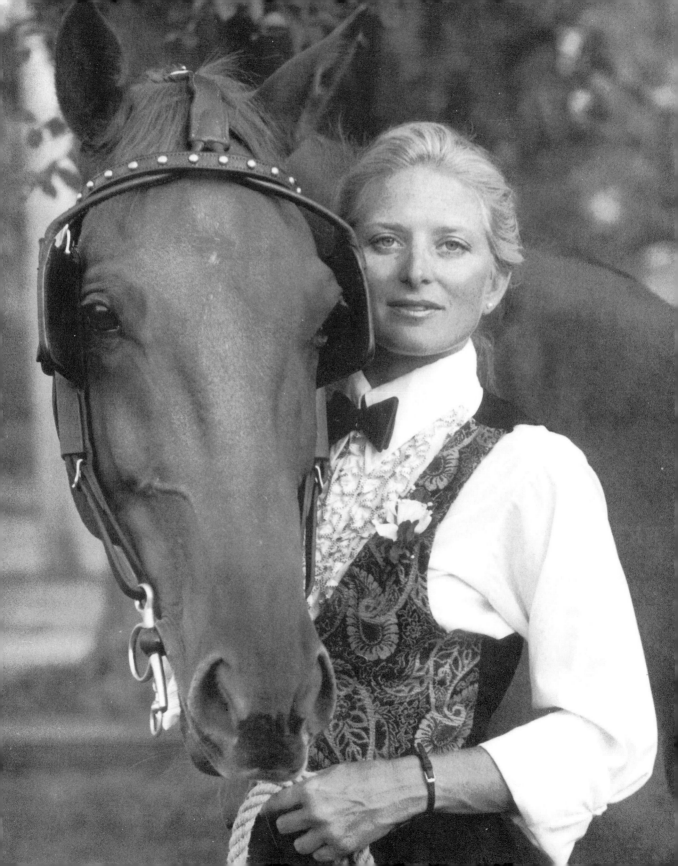

FROM AGES SEVEN TO TEN, I walked many miles beside roads and highways in Maryland collecting soda pop bottles for a two-cent refund on each. I managed to collect enough to buy three twenty-five-dollar U.S. savings bonds. In 1969 those matured bonds purchased my first horse, Timber, who became my friend for life.

In 1971, Timber became the stablemate to Silver. I tied trout-fishing flies in my spare time to be able to afford him. Thanks to Timber and Silver, I had the unconditional love that helped me through my teenage and early adult years. They saw me through two failed marriages and into a loving and successful third. I was on Silver, riding in a show, when my husband first saw me. The fact that Timber and Silver were a part of my life is the only reason I am a survivor of wounds too deep to share with people. My home was at the stable with them, where life was quiet and simple. They did not know they saved my life just by being horses.

PHOTO: Alice Walker

Carrie Itschner and Silver

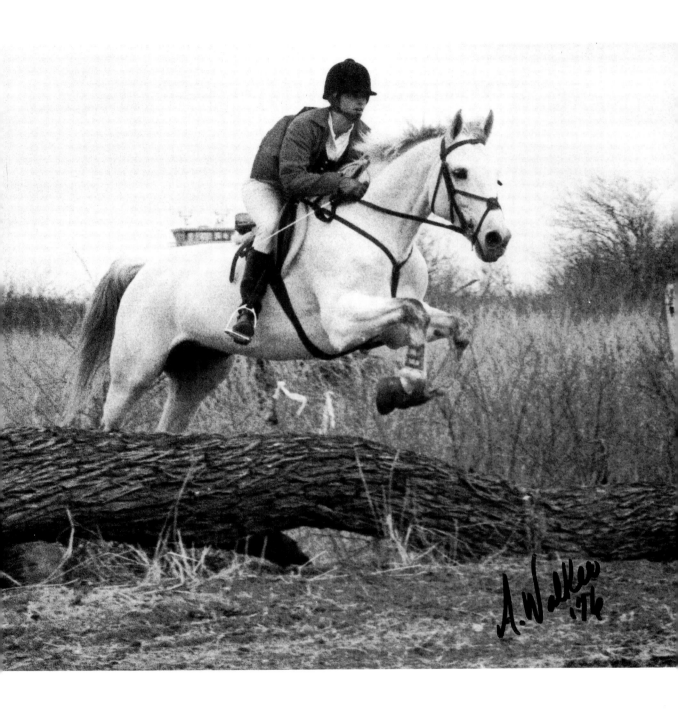

A. Walker '76

On October 3, 1990, my family and I went out of town. When we came back on October 8, I found that Micky and another horse, named Toby, were missing. I had bought Micky with my piggy bank money when I was thirteen — he was then ten months old. Who would steal my now-twenty-four-year-old horse? What would someone do with him? After five weeks of searching, placing ads in newspapers, sending and tacking up posters everywhere within a three-hundred-mile radius, as well as notifying several slaughterhouses around the country, I got a break and checked a particular auction house. The sales records showed a sorrel gelding and a bay mare. The gender was wrong on the bay, but I knew it was Micky. I found out who bought the horses and what had been done with them.

They had been shipped to Great Western Meat Company in Morton, Texas, on October 10. My heart sank. It had been seven weeks. I telephoned Great Western and asked if they still had my poster up, and they did. A ranch hand searched the pens, but Micky wasn't there. They said the shipment had been killed on November 15. Exhausted and heartbroken, I went out of town with my family for Thanksgiving. When I returned, there was a message on my answering machine: "Sheila, this is Ellen with Great Western Meats, and one of our men believes he found your horse in one of the feeders." I was elated. I couldn't believe my ears. I played the tape over and over again.

I made plans to take the week off and bring my friends Micky and Toby back home to California. The horses had been spared because of a breakdown in equipment and because there had been an overabundance of horses. Micky and Toby had been moved to a feeder down the road and gotten lost in the shuffle. They had been there seven weeks. Normally horses don't last more than three or four days. Micky is back home now and doing great. He's regained the hundred pounds he lost during his ordeal. I feel like the luckiest person in the world.

PHOTO: Margaret Vilas

Sheila Morlas and Micky

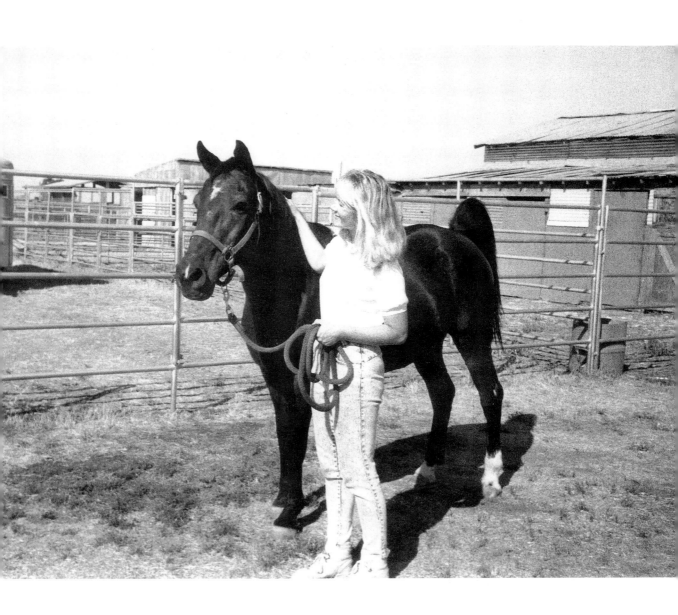

IT'S BEEN nineteen years since I first saw Suzy. She was a sorry sight, with abrasions all over her body, a rope burn on her neck, and a very mangy coat. I had been wanting to buy a donkey but was not quite ready, since I didn't even know how to care for one and didn't have a corral. Suzy's owner was proud of his training technique — hitting her between the ears with a two-by-four! I bought her that day.

The veterinarian came and examined her and doctored her various ailments. She determined that Suzy was at least fifteen years old. After all these years of being together, I marvel at the adventures we've survived. Suzy broke away from me on a pack trip and was lost for ten days in a national forest; a neighbor threatened her life and I had to move her out of town for three months; she foundered twice after breaking into the barn and eating half a sack of sweet feed (I had to stay with her for three days and nights, keeping her feet cool and walking her around each time it happened); she fell through a cattle guard and had to be pulled out by a crane; I could go on . . .

Suzy's incredibly intelligent, a master at opening gates by untwisting wire, untying knots in rope; she can even use the cheater sticks on wire gates to open them. She shakes hands only if she knows she'll get a treat and will go for a jog with me as long as I keep grain in my back pocket for her. For a thirty-four-year-old she's in amazingly good condition. My veterinarian tells me that Suzy is her oldest patient.

PHOTO: Donald F. Albert, Sr.

Beth Menczer and Suzy

68

Fɪɴᴇ ᴀɴᴅ Dᴀɴᴅʏ came into my life and proceeded to totally disrupt my peaceful and sensible existence in every conceivable way. Actually, Dandy belongs to my daughter Erin, whose romance with horses began at an early age. "Paint" and "Palomino" were among her first words, Breyer horses grazed in our living room, and riding lessons became an obsession around which our schedules revolved. Hundreds of conversations began with "When we get ours." But buying a horse was never a realistic possibility.

Dandy is a *gift horse*. Need I say more? When Erin announced that she had met a perfect stranger who had offered not only to give her a horse but also to haul him the two hundred miles to our home, I was stunned. Erin would not take no for an answer, and within a week she had found a stable where she could work off his room and board. Dandy cinched the deal when he neighed exuberantly as I walked into his barn to check him out.

Two weeks later Dandy, all 14.2 hands of him, arrived and took charge. To say that he was a little green is an understatement. He refused to even walk in a straight line and threw Erin three times in the same number of days. Erin's trainer took one look at him and shook her head in disbelief. Gradually, however, Erin's faith and persistence began to pay off. "That Pony" now hacks nicely, jumps three-foot fences, and does beautiful flying lead changes. A battle of will is still an important part of Erin and Dandy's relationship, but now they take turns letting each other win.

Dandy — gobbler of grapes, self-appointed stable manager, bucking bronc, and pony hunter — has taken hostage my time, my bank account, and unfortunately my heart.

PHOTO: Pat Rogers

Erin Mixson and Dandy
Courtesy of Ann Mixson

WHEN I MAKE A MISTAKE with my lasso, The Dude first gives me *that look*. He then waits patiently while I take the rope off his neck and try again for the cow.

PHOTO: Carol Lane

Amy Hill and The Dude

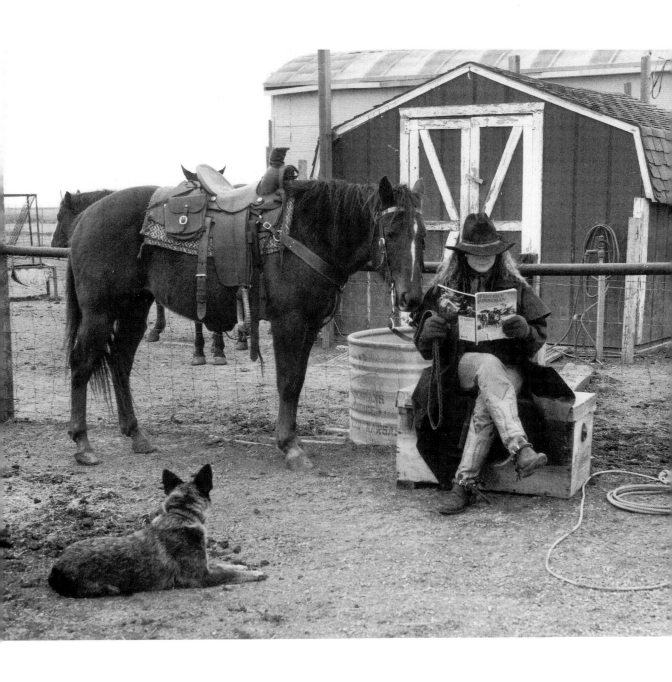

MY AWESOME PONY Idle Chatter loves to go fast and jump fences and walls. She just sails over them! It feels like we're floating together through the air.

PHOTO: Margie Arnold

Lisa Williams and Idle Chatter

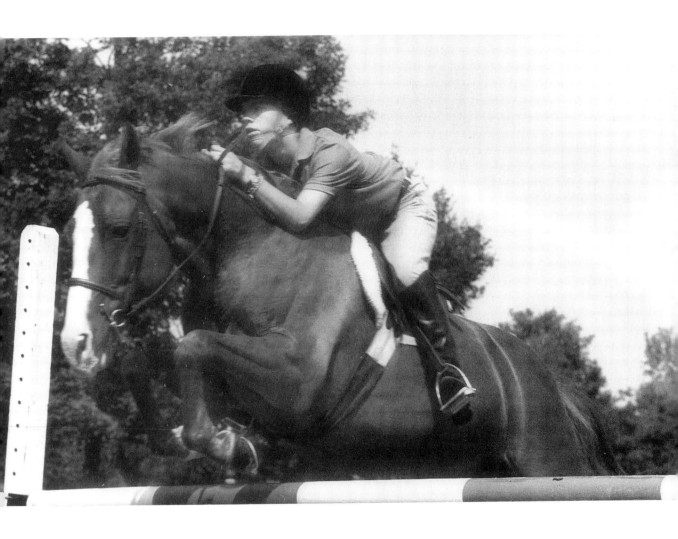

Town came to me just before my thirteenth birthday, and he left me ten years later, just after my twenty-third. He was my closest friend and companion during those years, and when the time came to choose a college, the comparative academic qualities of the schools that accepted me were secondary to whether I could bring my horse. It was during our last three years together that our relationship really became transcendent; we were no longer horse and rider, but a single spiritual entity that somehow occupied two vastly different bodies at the same time. I used to bring my books out to his pasture and study with him. Sometimes I would bring a kite, and he would trot around with his tail flagged and ears pricked, trying to grab the kite string.

When he died my friends came, and we sang to him and read a long poem about our life together. When he left, a part of my body was torn away and went with him.

PHOTO: Courtesy of Lori Berger

Lori Berger and Town

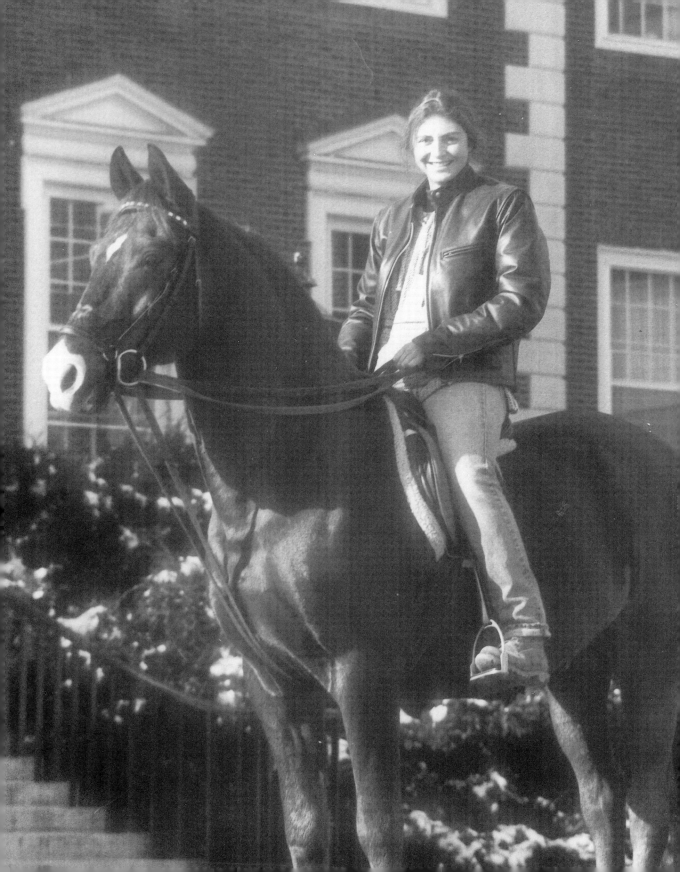

THOUGH K.J. did not meet all of my requirements when I decided to buy my first horse, she was sound and healthy. I have only fallen off twice in the past two years since I bought this unbroken mare! I went to every clinic, read every book, and watched every video I could get my hands on to learn to train her.

I even taught K.J. to climb snowbanks. Just kidding — this horse will do anything for food!

PHOTO: Frank Verley,
Verley Photography

Julie Dauer and K.J.

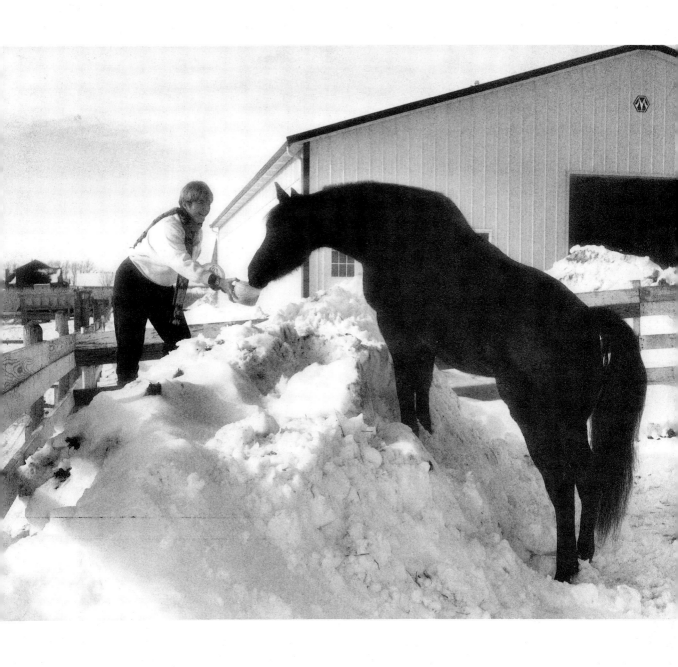

SOME MOTHERS pick up their children after school and take them to baseball or football practice, swimming or ballet lessons. Before picking up my daughter, I gather the horses in the pasture, sometimes getting injured (see my foot in the photo) because I haven't taken the time to put on proper shoes. I then load them into the trailer, hurry to town to pick up my daughter Dakota, and take her to her riding lessons. She has one horse for barrel racing and another for roping cattle.

It would be much easier to take my daughter to swimming lessons. Yet on hot, dry afternoons when the dust is kicked up as she passes by me in the ring, I watch with pride and know in my heart it is all worthwhile.

PHOTO: Sister Pauline Quinn

Trina Quinn and Cutter

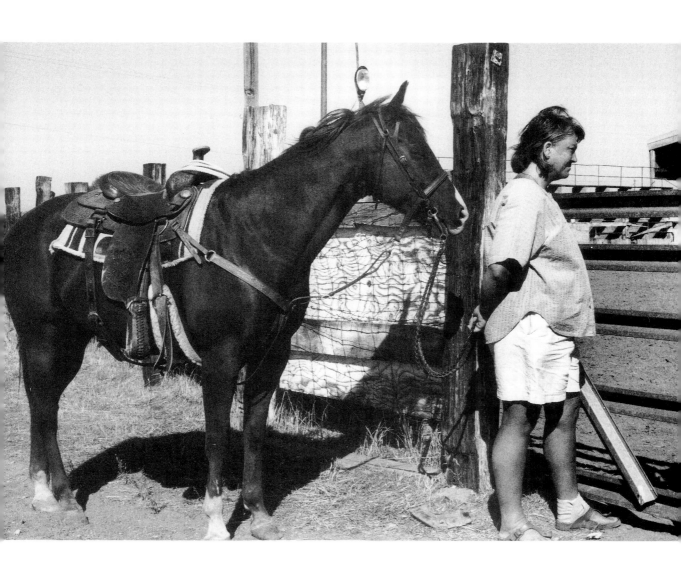

When I was eleven I was sure my parents were going to give me a horse for Christmas. On Christmas morning I ran downstairs feeling certain that I would find a saddle and a note telling me where to find my horse. Instead I got a china tea set.

Although I still don't have a horse of my own, I do have the horses at Fox Meadow Farm. I remember when Jesse first came. He didn't know much but was willing to try. Jesse is like a package waiting to be unwrapped. Will he become a special school horse, or will he be another tea set?

Photo: Michelle Segall

Havalah Schnurr and Jesse

WHILE I WAS riding my Pinto, Chief, in the Banning Stagecoach Day Parade, six clowns performed in front of me. Everywhere a horse had pooped, a clown planted a red rose, and another clown, with his watering can, sprinkled it, all along the three-mile route. I figured we'd get into the act, and I circled Chief around each rose. With no persuading from me, he put his head down and sniffed the roses — each time the crowd would roar. He did this in front of the parade judge stand en route, and I think this is why I won the Sweepstake Equestrian Trophy.

PHOTO: Marilyn Odello,
The Press-Enterprise

Natalie Gammey and Chief

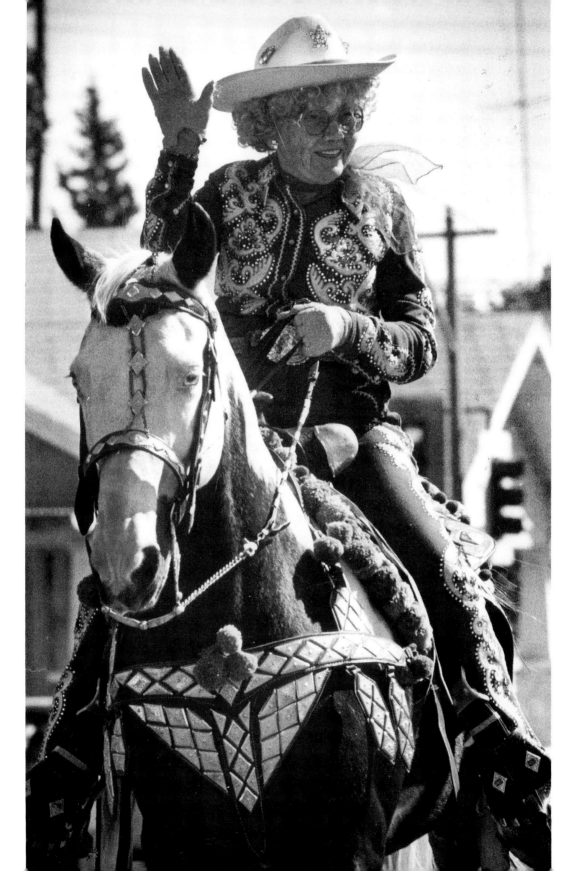

CAMPY has endured ill-fitting equipment, unsteady hands, and confusing reprimands from an inexperienced rider. While most teenage horses would retaliate under such conditions, Campy has remained good-natured in spite of all the mistakes I have made as a novice horse owner.

Although sometimes I've been frustrated with Campy's laziness, he's been surprising me lately with sudden outbursts of energy and emotion. Maybe he was just waiting all this time for me to learn the ropes.

PHOTO: Kevin Harris

Katrina Mueller and Campy

THE HORSE is pregnant and her name is Miss Hankey-Pankey. I'm too old to be pregnant but do like a hot tub after a day on the trail.

My grandparents were Arizona pioneers, and though I love the east, I often hanker for my western heritage. Since I have lots of nice western cousins who are all great riders, I have a wonderful reason to visit the west with my husband and play cowboy. Up on my steed I'm great at a walk. I sit tall in the saddle and wish I smoked so I could roll my own, pulling the string on the tobacco pouch with my teeth. Trotting is a kind of post-and-bounce situation that I find very stressful. I call it canteloping and heave great sighs of relief when we slow up. When I dismount I need at least a minute to unlock my knees, but I don't care. I love the whole scene and fantasize about the next trip west even as I take off my Stetson and put on my ski hat!

PHOTO: Margie Arnold

Margie Arnold and Miss Hankey-Pankey

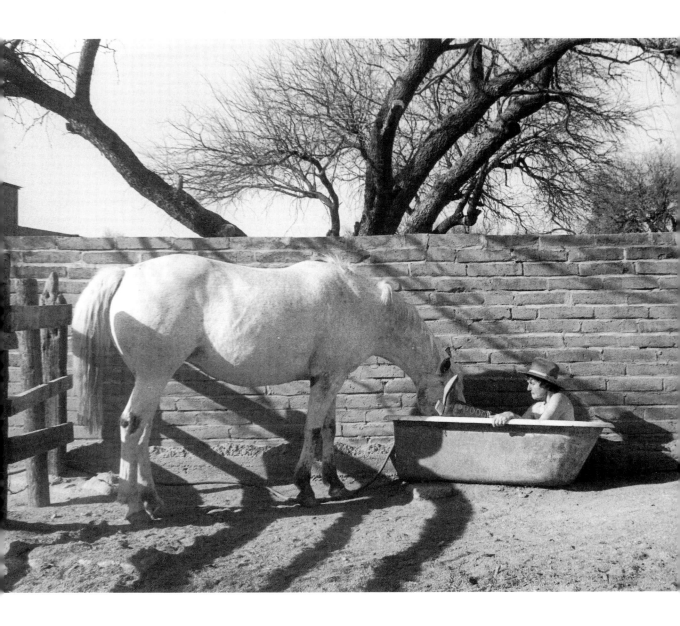

No matter what I asked of Monaco, he always gave 110 percent of himself. He was my teacher and my best friend. It was because of his great character that we were able to bring home the bronze medal for team dressage in the 1976 Olympic Games. Our score still stands as the highest to date in individual dressage for any American pair. I was honored and blessed to be able to work with him. I miss him.

PHOTO: Gayle Goddard-Taylor

Dorothy Morkis and Monaco

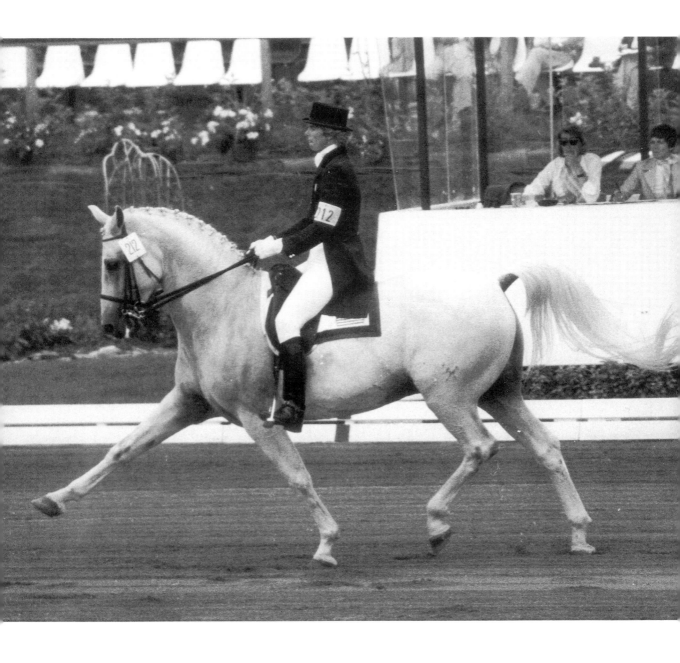

IF ONLY I COULD REACH OUT and remove that piece of straw from over her right eye, or untangle her knotted mane, but Pretty Girl is a wild Mustang. She was originally adopted out of the Bureau of Land Management in Susanville, California, in 1989 at age two and was bred when she was three. The family that adopted her took her foal, starved her, sent her to a trainer who knew nothing about taming Mustangs, and beat her.

I found her at a boarding stable in January 1991. I made arrangements with the BLM to re-adopt her. After four months she started looking good again. At the end of six months I could touch her on her nose. I can now stroke her forehead, nose, chin, cheek, neck, and shoulders. I get goose bumps when she lets me run my hand over a new area of her body. She just learned to lead and will now eat carrots or apples from my hand and do almost anything for grain.

Pretty Girl wants to learn as much as I want to teach her, but we are both afraid and cautious of each other. In this world we take so much for granted. We forget the value of love and trust.

PHOTO: Gay Currier

Nancy Freitas and Pretty Girl

I'VE HAD SEAMUS for at least twelve years. He's a typy little Morgan, 14.2 hands on his toes. He's a fast walker, a good mover, lively on the trail, but safe as a pup — as you can see — around the barn. Sometimes we get bored doing everything exactly the same way, so I take a rear exit. His look says he thinks I'm nuts, but then he often exits his stall tail first, so who's nuttier?

Seamus rides and drives, jumps, trailers like a lamb, and even though he's quite an escape artist, you can always catch him with a carrot or a few oats. He seems to enjoy life, and I sure enjoy him! A snappy ride in the woods takes my mind off work (I write the column "Ask Beth") and recharges my batteries. Even when we're not riding, it's fun messing around with this goofy horse.

PHOTO: Margie Arnold *Elizabeth Winship and Seamus*

W<small>HEN</small> T<small>ONY WAS ABOUT TWO</small>, in April 1991, he was seized from a farm in Virginia along with over thirty other Morgans. Near death from starvation, Tony would not have survived another week without care. He was taken with all the other horses to the Equine Rescue League Farm, where I, as a volunteer, saw a summer of miracles.

When Tony first came to the farm he did nothing but lie in his stall and moan. His poor skinny legs were bloated from capillary drainage, and he was full of worms. After the first few weeks, he began to lose the dead orange hair from his body and spent a month and a half as a bald horse. Luckily, it was summer. In just a few months Tony became a handsome, healthy horse. He grew a beautiful shiny coat and began to grow a Morgan mane.

While I could go on all day about his gorgeous looks, what is really important is how beautiful he is inside. He is the most trusting, affectionate horse, so gentle and quiet — except when it's feed time or treat time (grapes are his favorite). Tony is happy and healthy now, as every horse should be, and I am the luckiest person in the world to be able to keep him.

P<small>HOTO</small>: Lina Abirafeh

Anna Simms and Tony

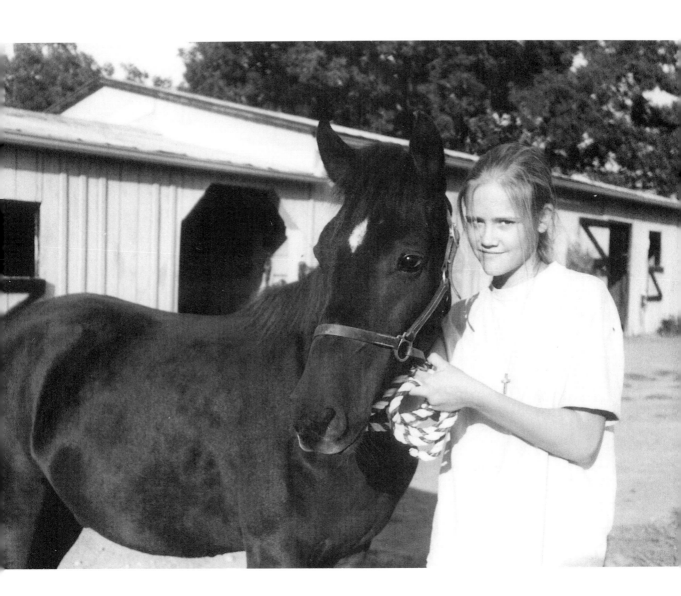

JILL IS A MULE. Her mother is a horse, her dad is a donkey. The first time I saw her I thought I had never seen an uglier animal. But by the end of our test drive, I was in love. Jill is a sweet and loving animal. She will stand for hours with her nose on the ground so I can reach the top of her head to give those long, beautiful ears a good scratching.

PHOTO: Denal Allen

Ann Firestone and Jill

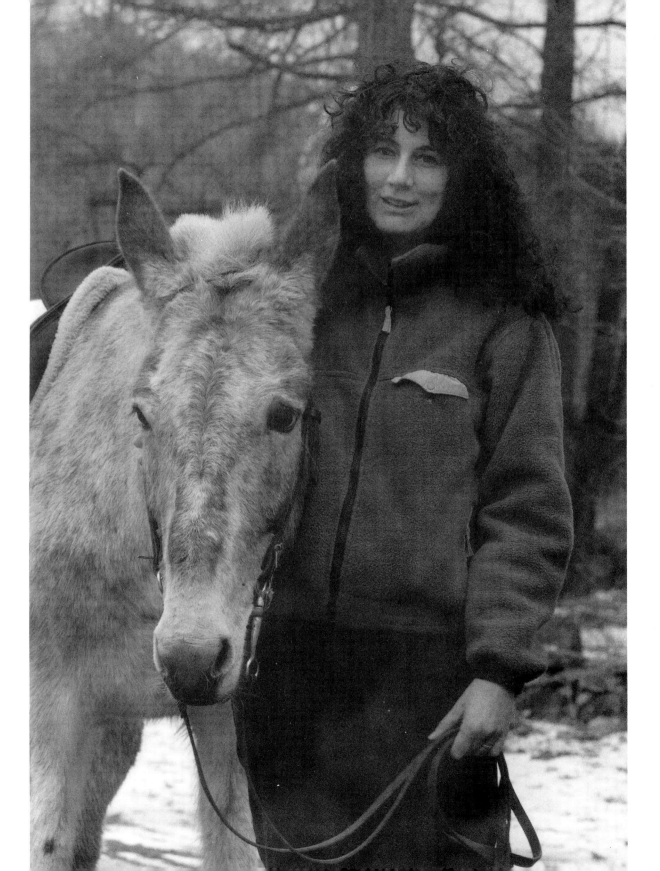

WHEN I WAS A LITTLE GIRL, every chance I got I would pedal my bicycle as fast as I could across the township to Manion Canyon, an Arabian breeding farm. In my eyes those barns held the most beautiful treasures on earth. I grew up dreaming of someday having one of my own.

There were always horses in my life, some very dear to my heart, but none to compare with what I had seen as a youngster peering over the stall door at Manion Canyon. Throughout the years I could always visualize those stall nameplates as though I had seen them yesterday: Ruffles, Radio, and The Riff. Often I would visit my hometown and drag my husband and children to see the progeny of the stallions I dreamed about as a child.

When I realized how old my dear mare of twenty was becoming, I returned to the Canyon to try to fill the void. I looked at many mares. None could take her place. Out of the blue, I asked for a snappy little stallion I had seen years before. Radio Active is here with me now. His sire's name was on one of those nameplates I had memorized as a child. He is as special as I dreamed he would be.

PHOTO: Justin Crowley *Carolyn Crowley and Radio Active*

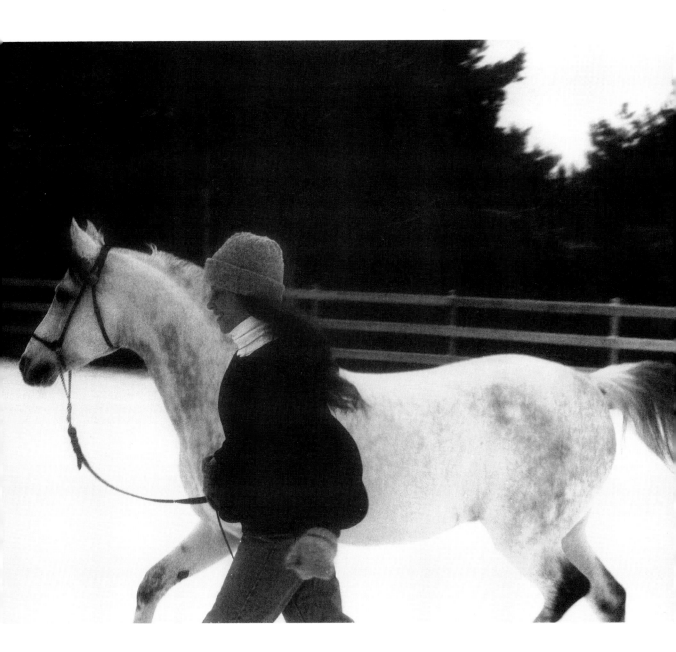

THE LAST TIME we rode was at Del Mar Fairgrounds, May 1987. Frosty Lake and I made a jump on the last obstacle out of the trail course. Terrific pain took away my breath and traveled through my back. The diagnosis was five collapsed vertebrae and multiple myeloma — bone marrow cancer. We finished second, but I was in a hospital bed for a year. Frosty retired with me, at twenty-two, and was put down due to seizures in April 1991. I am still under chemotherapy and holding my own.

We had a wonderful time showing, Frosty and I. He was a grand old champion, and I wish we could have extended our time together. But I'll never forget him and his almond eyes.

PHOTO: Rick Osteen Photography

Joyce Parson and Frosty Lake

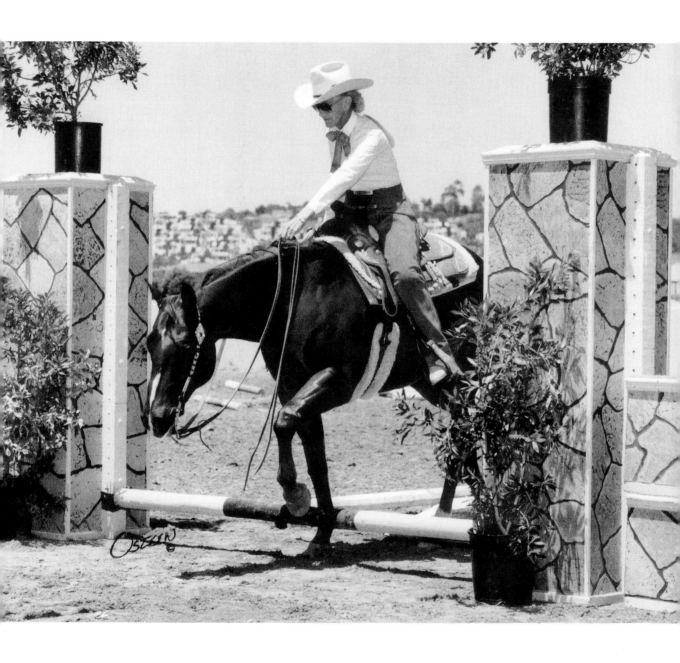

ABHAZIAS COMET is airy on her feet as was her Polish grandsire Comet. She is the result of my twenty-one years of breeding and training Arabians on a shoestring budget.

My love of royal pedigrees and good horses has kept me horse poor, yet emotionally stable, for the last thirty-five years. When first afflicted with "horsitis," and later caught in the sticky web of the related condition "Arabitis," like a bedraggled fly I could not escape. I was in horses' clutches, submitting to their every whim night and day, at their beck and call, running with checkbook or thermometer in hand, waving aside all difficulties in maintaining their absolute happiness. I ask you, in what other profession can one so totally surrender to such demanding, beguiling creatures and still come up smiling, loving every minute of it?

PHOTO: Kathy Jones *Daphne Tucker and one-month-old filly Abhazias Comet*

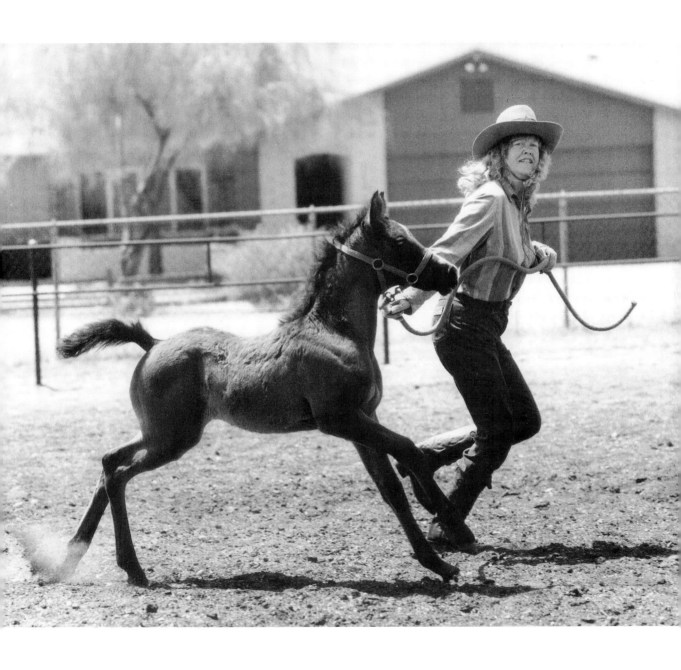

MY HUSBAND sees her as an open pit that money falls into and as the cause of my periodic trips to the emergency room. I see her as my friend, my confidant, and the preserver of my sanity. She is a superb athlete with a heart of gold.

It is true, my ex-racehorse can be a bit sporty. But after a year together, if I ask nicely, she'll plod down the road looking very much like a tired old cow pony. Ah, but when I ask her to go . . . there's really nothing else like it.

PHOTO: Andy Probert

Judi Probert and Sherry Baby

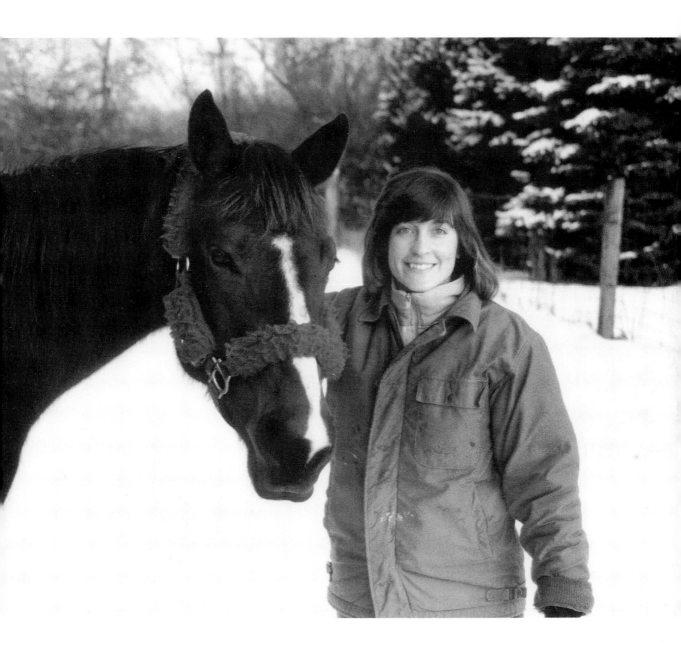

THE LAST CHANCE CORRAL of Shannock, Rhode Island, is a nonprofit project that provides a respectable alternative home for unwanted, abused, and neglected horses and ponies. Too often these fine equines end up on dinner tables in Japan and France, are destroyed, or are left to age without grace in some back lot. So, I bring them to the Last Chance Corral, tend to their aches and pains (emotional as well as physical), and reroute their lives with programs customized for their individual needs. Some of the horses need training, others discipline, others nourishing food, and still others just a chance. I open the door to their new life.

Horses throughout history have been part of myth and romance. They embody the very elements of grace, power, and freedom. For me they are magic. I can't bear even the thought that cold greed could bring a person to destroy a healthy horse without a thought to what he might have been to some small child or family.

I don't suppose I'll ever own my own horse again, for so many need me now and I could no longer give my heart to just one. They're all so special, and when I see them with their new families, at shows, or at home, loved and healthy, it fills my heart. All it takes is giving them one last chance and a little magic.

PHOTO: Martha Everson

Victoria Goss and Pac Man

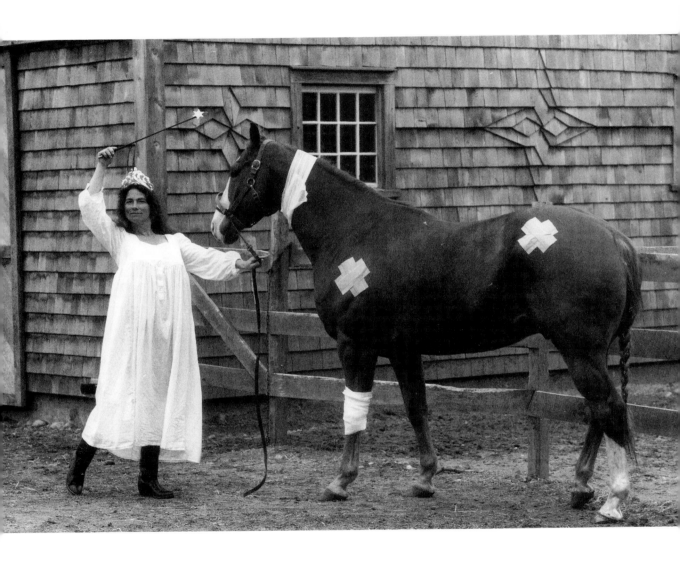

FROM TWO WINDOWS in our house I can see my horses in the pasture where they spend each night. In the summer Angel's whiteness stands out against the dark and green. In the winter her son, Cowboy, contrasts with the snowy landscape. Night or day I can spot one quickly, even with a side glance. It is always reassuring to know they're there.

PHOTO: Tom Nye

Ann Nye with Cowboy and Angel

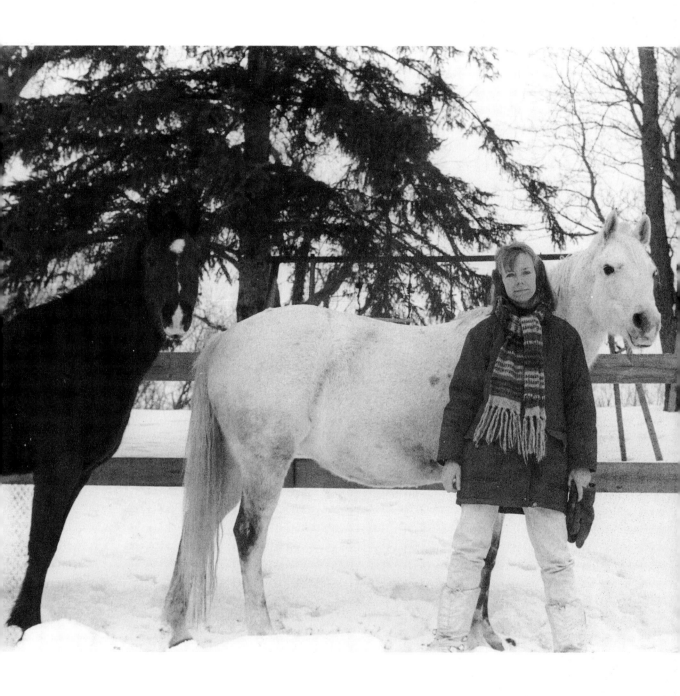

I RODE AS A YOUNG GIRL, and the love for horses I developed made me determined to have my own. Forty years later, after raising four sons, that dream came true.

Muffet April was a green three-year-old purebred Arabian mare when I got her and has been the joy of my life these past fourteen years — both as a riding horse, and now as an excellent driving horse. We learned the driving skills together, mostly teaching ourselves, and now have such enjoyment in our jaunts, especially to the beach.

PHOTO: Betsy Corsiglia Photo *Barbara Dutton and Frances Bradley with Muffet April*

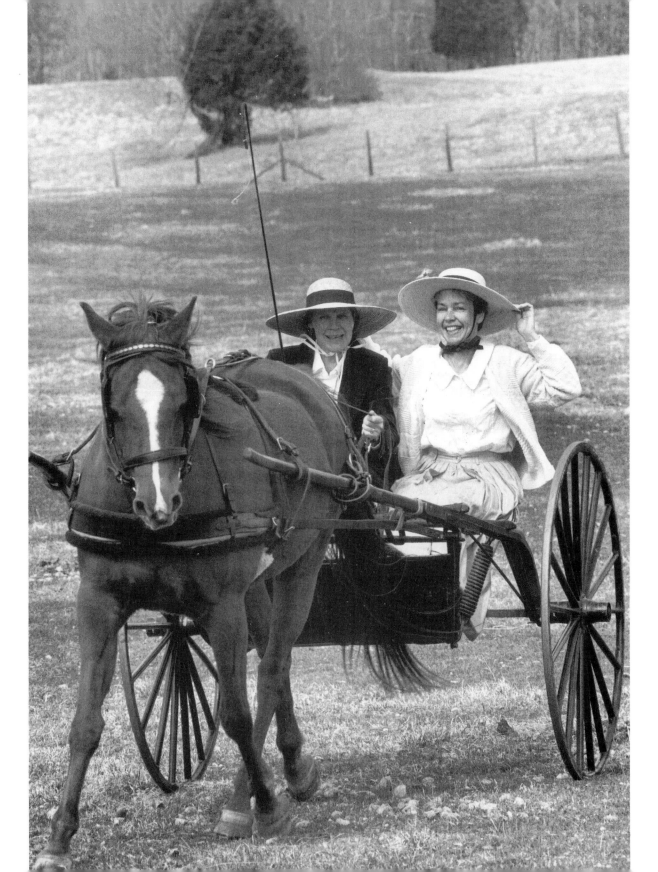

THE HAPPIEST DAY in Tam's life was when I bought Kingston. Now he had a younger brother who could do all the work while he lolled about in the pasture.

Kingston's specialty is dressage. I call him my dance partner because riding him is like floating on air. He loves his work and is a gentleman and a pleasure to be around. Sometimes I think I favor Kingston. Tam somehow will sense this and suddenly decide to make a big fuss over hearing my voice or to race excitedly to the pasture gate when he sees me there. Once in a while he'll even hand me his halter. I realize then that I love Tam and Kingston as I love my two-legged children — equally.

PHOTO: Photography Dan Moore *Deborah Barkin Fromer with Kingston and Tam*

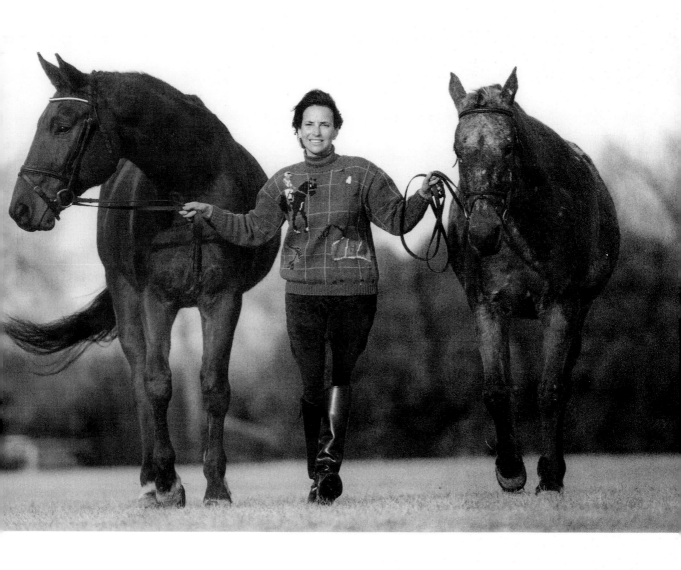

Our western heritage is alive in the two thousand wild horses that roam eighteen thousand acres of rich bluestem grassland of the Prairie National Wild Horse Refuge, in northeastern Oklahoma. Gathered off public lands, these horses were not adoptable, because of their age, unattractiveness, or temperament. They would have been sent to slaughter and made into pet food were it not for a group of humane activists, horse lovers, and schoolchildren from all over the country who put a stop to it. I have grown to love and respect them, not for their beauty but for their power and strength. Here, on my family's ranch, these survivors of drought and starvation can live out their natural lives, protected by law.

*Sally Hughes and horses from
the Prairie National Wild Horse Refuge*

PHOTO: © Mike McBride III

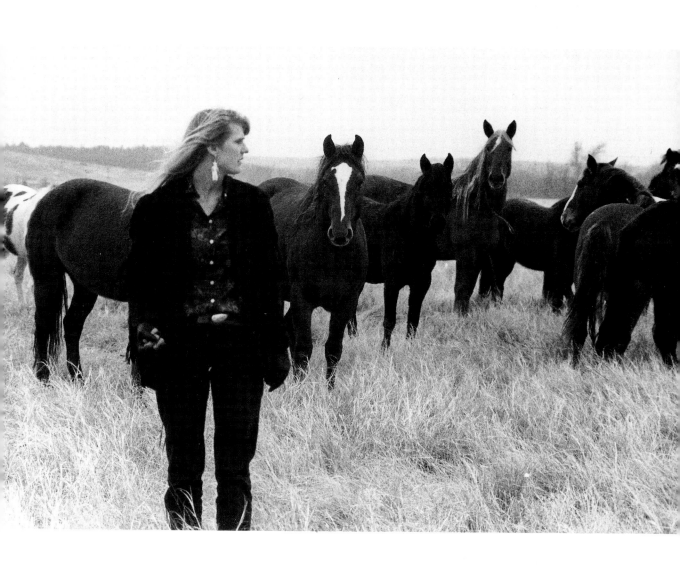